Pierre-Auguste Renoir
Masterpieces of Art

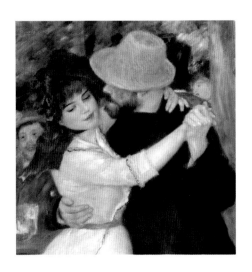

Publisher and Creative Director: Nick Wells
Senior Project Editor: Laura Bulbeck
Art Director and Layout Design: Mike Spender
Digital Design and Production: Chris Herbert
Copy Editor: Ramona Lamport
Proofreader: Amanda Crook
Indexer: Helen Snaith
Special thanks to: Gillian Whitaker, Frances Bodiam and Helen Crust.

FLAME TREE PUBLISHING
6 Melbray Mews
Fulham, London SW6 3NS
United Kingdom

www.flametreepublishing.com

First published 2016

16 18 20 19 17
1 3 5 7 9 10 8 6 4 2

Image Credits: courtesy Artothek: 67 and the following: 21 & 103 Hans Hinz; 58 Peter Willi; 92 Christie's Images Ltd; and Bridgeman Images and the following: 1 & 96 Museum of Fine Arts, Boston, Massachusetts, USA/Picture Fund ; 4 & 65 The Barber Institute of Fine Arts, University of Birmingham; 6 & 55, 82, 85, 100 Sterling and Francine Clark Art Institute, Williamstown, Massachusetts, USA; 9 & 53, 20 & 95 & 128, 22 & 110, 38, 45, 94 Musee d'Orsay, Paris, France; 24 & 112 Musee Picasso, Paris, France; 25 & 119 Bridgestone Museum of Art, Tokyo, Japan; 26 & 122, 62, 71, 107, 114, 115, 116, 123 The Barnes Foundation, Philadelphia, Pennsylvania, USA; 30 © Nationalmuseum, Stockholm, Sweden; 31 Museum Folkwang, Essen, Germany; 35 Wallraf-Richartz Museum, Cologne, Germany; 40 Fitzwilliam Museum, University of Cambridge, UK; 41 Museu Calouste Gulbenkian, Lisbon, Portugal; 42 Private Collection/Phillips, Fine Art Auctioneers, New York, USA; 43, 111 Private Collection/Peter Willi; 46 © Samuel Courtauld Trust, The Courtauld Gallery, London, UK; 50, 72, 97, 117, 121 Private Collection; 56 Fogg Art Museum, Harvard Art Museums, USA/Bequest of Grenville L. Winthrop; 66, 69 National Gallery, London, UK; 80 Museu de Arte, Sao Paulo, Brazil; 84 Minneapolis Institute of Arts, MN, USA/The John R. Van Derlip Fund; 90 Musee de l'Orangerie, Paris, France; 101 National Gallery of Art, Washington, USA ; 104 Private Collection/Photo © Christie's Images; 118 Kunsthistorisches Museum, Vienna, Austria; and Scala, Florence and the following: 51 © 2015. Museum of Fine Arts, Boston. All rights reserved; 73 © 2015. Image copyright The Metropolitan Museum of Art/Art Resource; and Superstock and the following: 13 & 75, 14 & 68, 70; 18 & 91 ACME imagery; 19 & 89 Buyenlarge; 33 Iberfoto; 106 Fine Art Images; and © The Granger Collection/Topfoto: 120; and Wikimedia Commons and the following: 7 & 34, 54, 99 DcoetzeeBot/public domain; 10 & 47 Hohum/public domain; 15 & 86, 88 Philafrenzy/public domain; 16 & 102, 63 Oxxo/public domain; 32 Oxxo/public domain; 44 Pimbrils/public domain; 87 Crisco 1492/public domain; 124 Salwadordali/public domain; and Google Cultural Institute and respective museums: 3 & 79, 8 & 36, 12 & 59, 17 & 78, 23 & 113, 27 & 125, 29 & 60, 37, 39, 52, 57, 64, 74, 81, 98, 105.

ISBN: 978-1-78361-718-0

Printed in China I Created, Developed & Produced in the United Kingdom

Pierre-Auguste Renoir
Masterpieces of Art

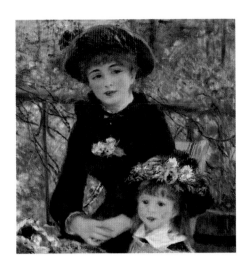

Julian Beecroft

FLAME TREE
PUBLISHING

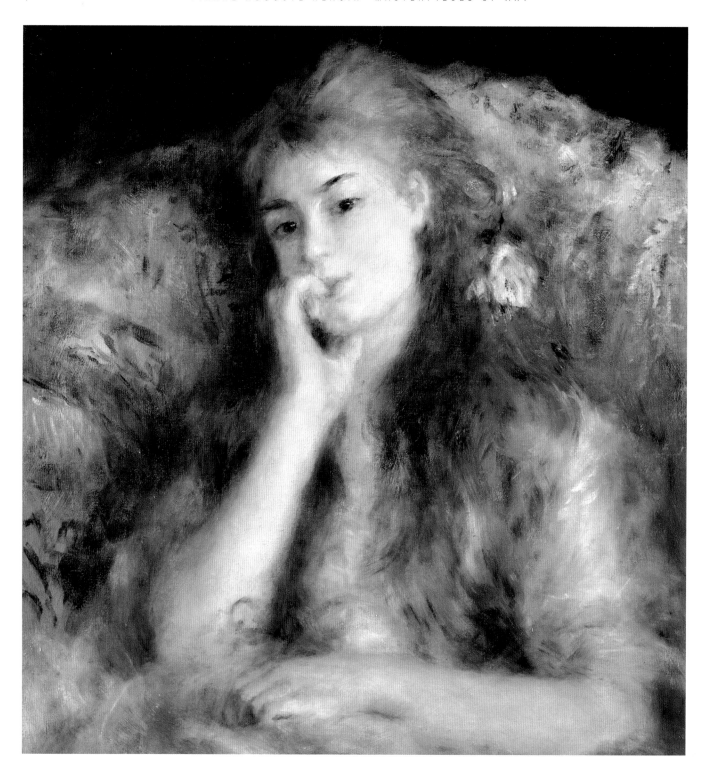

Contents

Pierre-Auguste Renoir: La Vie en Rose

In the autumn of 1915, while war raged a few dozen miles to the east, the elderly Pierre-Auguste Renoir (1841–1919) would sit day after day in his Paris apartment on the rue Rochechouart talking to his son, the future film director Jean Renoir (1894–1979), about his long and productive life. By now the elderly painter was unable to walk and in constant discomfort and pain. The one thing he could still do was what he had always done almost compulsively: he could paint. From *Renoir, My Father* (1962), the memoir Jean wrote of his father some 40 years later, there emerges an affectionate portrait of a contradictory man who was not only revered around the world in the last decade of his life, but was also much-loved by most of those who knew him.

'Monsieur Rubens'

Renoir was born in Limoges in 1841, but his impressions of one of the great centres of French porcelain manufacture were only half-formed when the family moved to Paris in search of better circumstances when Renoir was four years old. His father was a tailor, but while the family were not well-off at the best of times, they did live in the centre of the city, in the shadow of the Tuileries Palace then occupied by King Louis Philippe I (1773–1850). Renoir revelled in the life of the street and delighted in the occasional appearances of Queen Maria Amalia (1782–1866), leaning out of a window of the palace and throwing sweets to the children waiting below.

Before long, the monarchy had once again been swept away, and a few years later Renoir, aged 13, had begun work as a porcelain painter for a factory making pieces in imitation of the wares of his former hometown. Within a very short time, he was being paid two sous per

piece, mostly for pastoral scenes that evoked the Rococo decoration of the *Ancien Régime*, or three sous for those bearing a likeness of Marie Antoinette, a motif he had quickly mastered. Indeed, Renoir was so accomplished that before long he was allowed to copy nudes from a book his mother had given him, called *The Gods of Olympus by the Great Masters*, in mythological scenes that earned him the nickname 'Monsieur Rubens' among his fellow workers. The nude, the portrait, the landscape: there in miniature are three of the main genres that would occupy Renoir for the rest of his life.

The Atelier Gleyre

Eventually, industrial processes introduced in the late 1850s put paid to the porcelain painters' trade. However, this setback was only temporary as Renoir was soon earning a good living painting waterproof blinds, and then murals on the walls of Paris cafés. In his

lunch breaks he took himself to the Louvre to sit and sketch antique sculptures and the works of those masters of the French Rococo who would remain dearest to him throughout his life – Jean-Antoine Watteau (1684–1721), François Boucher (1703–70) and Jean-Honoré Fragonard (1732–1806) – as well as those of the great virtuoso of Baroque painting, Peter Paul Rubens (1577–1640).

By the early 1860s Renoir had saved enough to train as a painter and was admitted to the École des Beaux-Arts. At the same time he also enrolled in the studio of Marc-Charles-Gabriel Gleyre (1806–74), a meticulous painter and generous teacher among whose pupils during the same period were three who would become important not only to Renoir but to the future course of Western art: Frédéric Bazille (1841–70), Alfred Sisley (1839–99) and, above all, Claude Monet (1840–1926). Gleyre was impressed with the young Renoir's facility but had doubts about his motivation, challenging him early on that he obviously painted simply for his own enjoyment, to which Renoir retorted: 'But, of course, you can be sure that I wouldn't do it if I didn't enjoy painting.' It is a statement that announced not only the new attitude to art that Renoir and his friends would develop in the coming decades, but also a new independence of mind that would usher in the modern world.

The Forest of Fontainebleau

At Monet's instigation, the group of friends, which also included Camille Pissarro (1830–1903) and Paul Cézanne (1839–1906), took to the forest of Fontainebleau, to the south of Paris, to paint outdoors or *en plein air*, an article of faith for the burgeoning movement for years to come and still a tactic we associate strongly with what has since become known as Impressionism. But in choosing that area they were consciously following the example of painters of the landscape school long established in Barbizon, a village on the forest's northern edge, such as Jean-Baptiste-Camille Corot (1796–1875), Charles-François Daubigny (1817–78) and Narcisse-Virgilio Díaz de la Peña (1807–76).

One day, while painting alone in the forest, Renoir was ridiculed and then attacked for his painter's get-up by a group of young rowdies who had come down from Paris. He would have been beaten to a pulp had it not

been for the fortuitous arrival of Díaz de la Peña, who saw off the attackers and helped Renoir to his feet. Díaz picked up the overturned easel to take a look at what the young fellow was painting. He was impressed but advised Renoir to lighten up his palette by doing away with the bitumen, a substance commonly added to oil paint in the nineteenth century to impart deep dark tones. Such a turning towards the light was a practice that the Impressionists would soon turn into a credo.

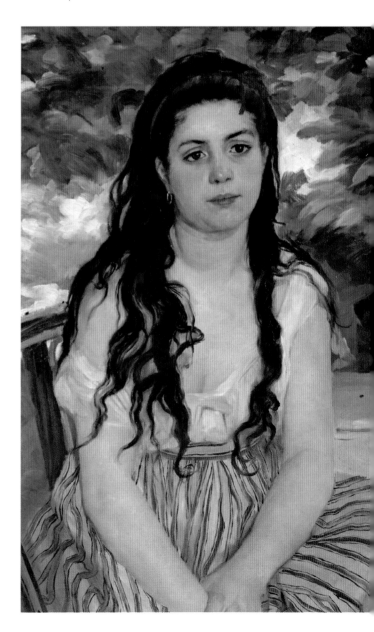

Looking to Manet

At the time the only route to success for any young artist was through
the Paris Salon, whose hanging committees had decided preferences
for certain supposedly more serious genres of painting – above all,
history painting. These were of no interest to Renoir and his group,
who took their lead, above all, from Édouard Manet (1832–83),
whose paintings from the early 1860s, such as *Olympia* (1863) and
Le Déjeuner sur l'herbe (1863), had shocked the Paris art scene by
subverting the conventional genres with a new attitude to the world
and its depiction. Indeed, Manet's unsettling influence can be felt in
some of the portraits Renoir painted in the late 1860s, such as *In the
Summer* (1868, *see* pages 7 and 34) and *The Engaged Couple,* or *The
Sisley Family* (1868, *see* page 35).

La Grenouillère

By then Renoir had achieved early and perhaps unexpected success
with the Salon when his *Dancing Esmeralda* was selected in 1864, but
as soon as the exhibition was finished he destroyed the picture, a clear
example of the independent spirit he would need to create a new kind of
art. Although Renoir would in fact be drawn back time and again to the
great tradition of painting for which the Salon believed it stood, the young
painters had already committed themselves to depicting the ordinary life
of the people they knew. Renoir, in particular, was drawn to the social life
of Paris and its environs which they all enjoyed, and it was in this spirit in
the early autumn of 1869 that Renoir and Monet set themselves down
on the bank at La Grenouillère, a popular watering hole on the Seine just
to the north-east of Paris where they often socialized themselves.

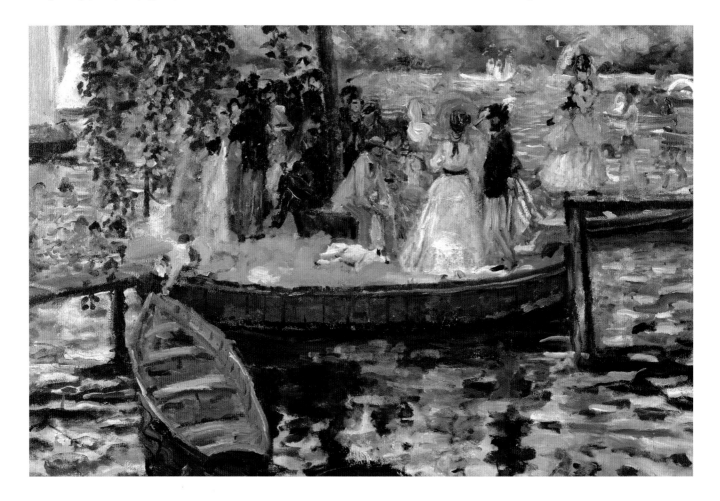

Instances of two great painters embarking simultaneously on a joint venture are fairly infrequent, so the pictures Monet and Renoir executed shoulder to shoulder at La Grenouillère (1869, *see* left and page 36) would constitute a fascinating historical moment even if they had been relatively conventional depictions. But the fragmentary paintings both of them made – in which the sense of a focal subject is dissolved in the dabs of colour and the reflected momentary light that pervade the scene – announced not only a new way of painting but a new way of seeing the world, like a brief glimpse imprinting itself on the mind. Or, as Renoir put it later with his customary flippancy, 'One morning, one of us had run out of black; and that was the birth of Impressionism.'

The Reluctant Revolutionary

Such an attitude of underplaying both his achievements and his aims was characteristic of this reluctant revolutionary but, even so, over the next few years Renoir would be as firmly committed to the new principles as any of the group, and as instrumental in motivating and organizing its activities. But if the group sensed that their moment was close at hand, its fulfilment would be deferred the following year by the advent of the Franco-Prussian War. Monet, a pacifist and now a father, fled to London along with Pissarro; Renoir joined the cavalry, haunted by the thought that if he tried to avoid the conflict, another man would die in his place (though, in fact, he was never required to fight). And the tight-knit group of painters would not be unaffected by the war, as Bazille, a close friend, was shot and killed in late summer at Beaune-la-Rolande to the south of Paris.

It was a time of upheaval that did not end with the French defeat. After spending the war in the south-west of France, far away from the fighting, Renoir returned to the capital at the height of the Paris Commune the following year and was nearly lynched by one of the mobs rampaging around the city. He retreated to his parents' house at Louveciennes, close to Versailles, and spent the summer painting landscapes with Sisley, who was living with his wife at nearby Ville-d'Avray. It was during the early 1870s that Renoir painted some of his finest landscapes, images of pure Impressionism (as this style would soon come to be known), such as *The Gust of Wind* (*c.* 1872,

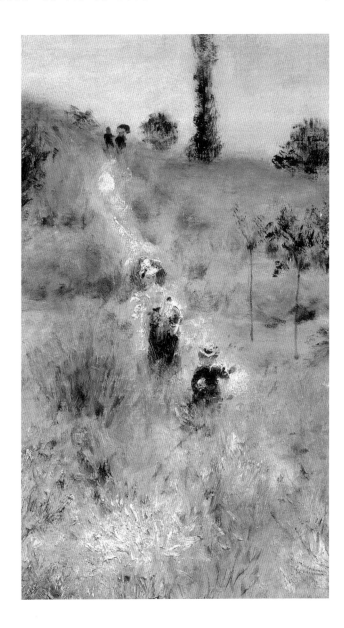

see page 40) and *The Path through the Long Grass* (*c.* 1875, *see* above and page 53), which also demonstrate the influence of Corot, a landscape painter of the mid-nineteenth century whom the younger painters all admired. But while Corot did indeed make *plein air* sketches, he was essentially a studio painter in the approved manner, painting often from memory and restricting his palette so as to create subdued, sober landscapes with an archetypal character rather than the immediacy of time and place that was the new group's explicit goal.

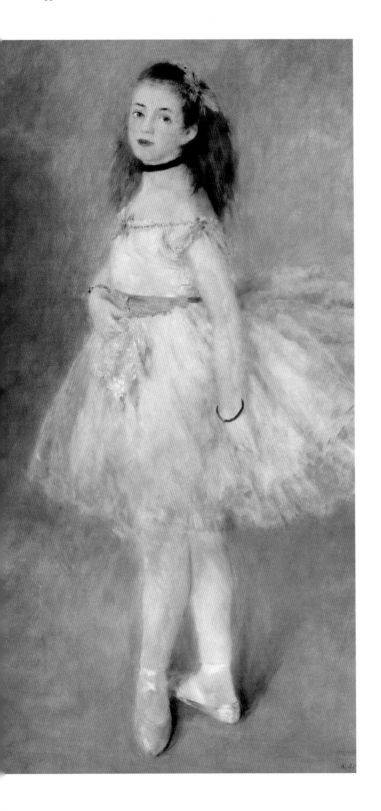

A Scandal without Success

In the middle of 1871, Monet and Pissarro returned from London, having been introduced there to Paul Durand-Ruel (1831–1922), the Paris art dealer whose faith and innovative business acumen would lead eventually to the triumph of this new style of painting. For now, for a couple of years in the early 1870s, Durand-Ruel bought heavily from the new group of painters, and the confidence they derived from his enthusiastic support emboldened them in April 1874 to hold what has since become known as the First Impressionist Exhibition. As well as Renoir, Monet, Sisley and Pissarro, the exhibitors included Edgar Degas (1834–1917) and Berthe Morisot (1841–95) in what is now seen as one of the greatest group shows in the history of art but was roundly attacked by the gentlemen critics of the Paris press. It was one of these men, Louis Leroy (1812–85), who coined the term 'Impressionism', an epithet of ridicule which the artists themselves soon embraced, though it remained a term that Renoir rather disliked. It is hard to believe that even a work such as *The Dancer* (1874, *see* left and page 47), which seems a sweet, almost sentimental image to us today, was mocked by Leroy when he described the dancer's legs as being 'as cottony as the gauze of her skirts'. Of course, he was correct in his visual analysis: Renoir's figure is dreamy and insubstantial, a creature from a parallel universe when compared to the academic portraits that won perennial favour with the Salon. Unused to the new painting, the critics could not make sense of what their eyes were telling them.

The Early Patrons

Nevertheless, the critcs' opinion carried weight, and in financial as well as critical terms the revolutionary exhibition was a disaster. What is more, it coincided with a global depression that had begun the previous year and would last until almost the end of the decade. Durand-Ruel, whom Renoir and his friends had relied on for income in the previous few years, suddenly found himself with a huge holding of Impressionist paintings that he could not shift, and was forced to tell his protégés that he would not be able to take any more. So Renoir turned to portraiture, a genre in which he excelled and by which he had scratched out a living in the later 1860s.

At first, he was forced to rely for models on friends and acquaintances who had no hope of paying him, but whose portraits Renoir hoped would attract the attention of supporters of the new style of painting. To a certain extent that proved to be the case as, following the Second Impressionist Exhibition in 1876, new enthusiasts came forward to buy what have since become some of the classic Impressionist images. Principal among these were Gustave Caillebotte (1848–94), himself a gifted painter and the scion of a wealthy family who bought heavily from his fellow Impressionists in the 1870s, amassing a superb collection; and Victor Chocquet (1821–91), a minor customs official who wore threadbare clothes so that he could afford to indulge his passion for art, until his wife came into an inheritance that allowed him free rein. Renoir was more than merely grateful for such assistance: later in life, he told his son Jean with apparent sincerity that 'It's the art-lovers who do the painting. French painting is the work of Monsieur Chocquet,' calling him, 'the greatest art collector since the days of the kings – or perhaps of the whole world, since the Popes'.

Moulin de la Galette

This was a fond exaggeration, of course, but also indicative of a humility that endeared Renoir to many and is clearly apparent in the trust and warmth that exists between artist and sitter in some of the many portraits of this period, an impression only intensified by the busy, enthusiastic brushwork of paintings such as *Portrait of Jeanne Samary* (1877, *see* page 67), the frank depiction of a famous young actress of the Comédie Française. But Renoir would never be satisfied with the life of a portrait painter, no matter how lucrative, and the income he derived from these sources in fact allowed him to embark on what would be perhaps the most ambitious work he would ever paint: *Ball at the Moulin de la Galette* (1876, *see* below and page 60).

Renoir had conceived of a monumental canvas depicting the revellers at one of the outdoor dance venues that were then springing up around Paris. At some expense, he rented a house in the rue Cortot,

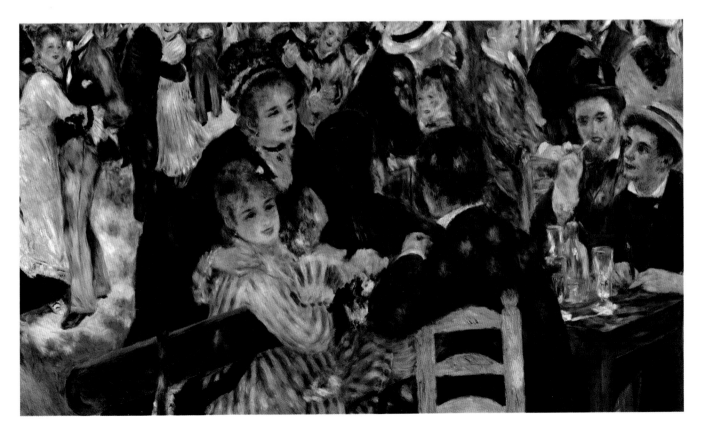

close to the Moulin de la Galette in the district of Montmartre. In the mid-1870s, the *moulin* had only just ceased being a working windmill and was still surrounded by fields that stretched out to the north of the city. Renoir needed many models for the milling crowds in the background of his intended work, so with typical politesse he set about befriending the mothers of the young girls of the neighbourhood, to whom he offered to pay a small sum. In the foreground, he set his friends in an arrangement that he worked at in many studies over some 18 months before completing what quickly became an icon of Impressionism, an embodiment of the carefree spirit of the movement, and which is now an emblem of the city in which it grew.

Fêtes Galantes

In this work and in *The Swing* (1876, *see* right and page 59), completed in the same year, Renoir was in fact drawing quite explicitly on the genre of amorous festivities in a pastoral setting invented by Watteau some 160 years earlier, the *fête galante* – the kind of scenes he had painted on to porcelain as a boy. As such, in departing from the often morose seriousness of the narrative painting of his own time, in celebrating the vividness of the present moment rather than brooding on the past, the content of these works is quite as radical as the way in which they are painted. As the painter later put it to his son, Jean, 'what seems most significant to me about our movement is that we have freed painting from the importance of the subject', by which he meant the literary or narrative associations of that subject, which could not help but interpose themselves between the artist and their direct experience of the world.

And in their use of dappled light filtering through trees, Renoir's modern *fêtes galantes* also realize the full implications of the pictures of La Grenouillère completed some seven years earlier. In a way that was still very similar to the approach of his friend Monet, Renoir draws the viewer's attention away from the interactions of the various protagonists towards the transfiguring effects of light. Indeed, the models in these paintings seem perhaps not entirely real, as if they themselves might have fallen under the spell of the light that caresses them, caught up in some modern-day midsummer night's dream.

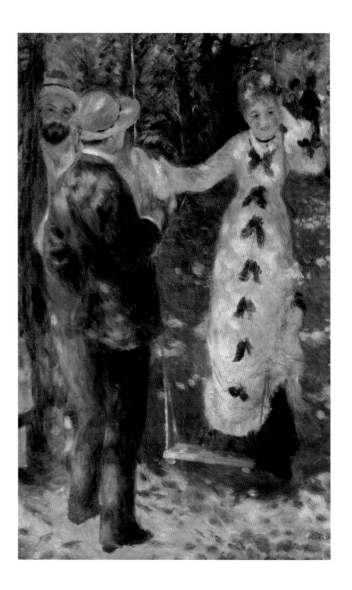

The Venus of Impressionism

Such an apprehension is at its most intense in what we might call the Venus of Impressionism, *Study, Torso, Effect in Sunlight*, known as *Nude in Sunlight* (*c.* 1875–76, *see* page 58), in which the model seems to be emerging from both the clothes she has partially discarded and from the apparently natural but dreamlike background in which she abides. Indeed, such is the kaleidoscope of colours with which her skin is depicted – again the effect of dappled light beneath some unnamed Arcadian grove – that she seems to have been made

from the same stuff as the environment that surrounds her, into which at any moment we imagine she might easily dissolve. Such a mirage of human beauty and its relationship with the natural world seems to extend Impressionism into a realm beyond the everyday miracles that these painters had made it their business to celebrate; but it also points the way not only back to the long tradition of the female nude in Western art, but forward in the direction that Renoir would come to travel some years hence. Not that the critics had any sympathy for such a subtle picture. Indeed, one who saw it at the Second Impressionist Exhibition in April 1876 described the nude figure as 'a mass of decomposing flesh with green and purple spots that indicate the state of total putrefaction in a corpse'.

The Portrait Painter

It was a disheartening reaction, just as the show overall was a venture even less successful than the first. Renoir failed to sell any paintings, so it was just as well that his reputation as a portrait painter was growing steadily. In the mid-1870s he began attending the private salon of the publisher Georges Charpentier (1846–1905), and the Charpentiers had soon commissioned several portraits from Renoir, including a large family portrait of *Madame Charpentier and Her Children* (1878, *see* page 68) that would mark a turning point in his career. Chastened by the indifference of the official Salon to the new painting, not to mention the continuing hostility of the press, in this painting and another, a full-length portrait of Jeanne Samary (1857–90), which he submitted successfully to the Salon of 1879, Renoir consciously reined in the sketchier aspects of the Impressionist technique he had developed over the previous several years, giving the figures greater clarity of line and the backgrounds a greater level of realistic detail. The composition of both pictures is also balanced and conventional: the Charpentier family group is arranged in a pyramid with, at its apex, the matriarch's watchful and well-meaning face. It is a flattering and dignified portrait, such as Renoir was becoming accustomed to providing.

Though naturally less inclined than many of his fellow Impressionists to explore the possibilities of form, Renoir also did not have the luxury of inherited wealth, unlike Manet, Degas or Cézanne, and

so was not at liberty to take risks in such paintings if he wanted to keep a roof over his head. Indeed, many of the pictures he was now being commissioned to paint were portraits of the children of wealthy Jewish or Protestant bankers, the second stratum of Parisian society, who wanted faithful likenesses of their beloved offspring painted in a modern style. As a result, images such as his portrait of *Marguérite-Thérèse Bérard* (1879, *see* page 73) or *Portrait of Mademoiselle Irène Cahen d'Anvers* (1880, *see* below and page 75) are conventional but still exquisite depictions of childhood innocence and naturalness with few equals in the history of art.

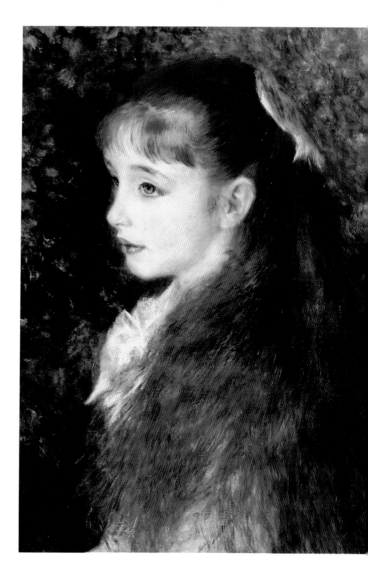

A Painter in Ordinary

The Charpentiers were certainly pleased with his work, paying Renoir 1,000 francs for the portrait of *Madame Charpentier and Her Children* (*see* below and page 68), a decent figure for a painter who was yet to properly establish himself. But such an accomplished picture was not enough to guarantee him success at the Salon, where most paintings were so disadvantageously hung as to be ignored by critics and public alike. Step forward Madame Charpentier (1848–1904) herself, with whom Renoir seems to have enjoyed a fruitful if slightly servile relationship; he refers to himself in one missive to her as her 'painter in ordinary', a reference to the court painters of the eighteenth century that he so admired and whose more artisanal role he would probably not have objected to carrying out. He was certainly happy enough when Madame Charpentier, a woman not without vanity who happened to enjoy considerable influence with members of the Salon's

hanging committee, managed to secure the picture a prominent position in that year's show. As a result, the critics took Renoir's work seriously at last, finding the painting both suitably conventional and sufficiently unconventional to merit an approving word. Such was the tightrope that a young painter had to walk.

It did the trick. Over the next few years enough commissions came his way that Renoir was not only freed from having to choose between eating a decent meal and buying paints – as had sometimes been the case in the past – but formed new friendships, such as that of the diplomat and financier Paul Bérard (1833–1905), for whom Renoir painted some 40 canvases between 1879 and 1884. During this period he stayed for long intervals on many occasions at Bérard's château of Wargemont near Dieppe, and gained introductions to other potential patrons, among them the Blanche family, who commissioned Renoir to paint decorative panels in their new house.

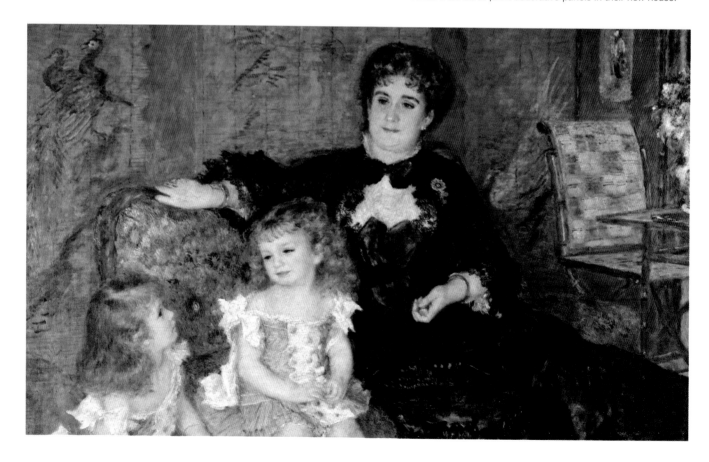

From the observations of people such as the Blanches, an image has since grown of the now not-so-young painter as a rather nervous man, uneasy, even twitchy, in company and lacking in social graces. But others, such as Paul Bérard, were clearly less inclined to find fault, in his case forming a lifelong bond with the painter on what appears to have been the basis of equals. However, as we will see, there were perplexing aspects to Renoir's personality that modern sensibilities would find offensive, and which point to a decidedly conservative, even reactionary view of the world that would inform his later work.

In the Footsteps of Delacroix

By the start of the new decade, indeed, Renoir had serious misgivings about associating himself with the revolutionary movement he had helped to found, fearing with some justification that his sales to a wider public were directly harmed by the perception of him as an *enfant terrible*. But his newfound financial ease allowed him the freedom to go abroad for the first time in his life, so in early 1881 he travelled to Algeria, following in the footsteps of one of his heroes, Eugène Delacroix (1798–1863), who had made the same journey half a century earlier. Renoir was fascinated with the culture and the people of the country and made a number of portraits and landscape paintings, such as *The Mosque*, or *Arab Festival* (1881, *see* right and page 86), whose exuberant movement and colour – in particular the strong use of red in the fezzes that the men in the festive crowd are wearing – might have been the work of the great French Romantic himself.

Returning to France, Renoir now embarked on another major canvas of Parisian social life that has since become one of the most beloved Impressionist images. *The Luncheon of the Boating Party* (1880–81, *see* page 78) was executed once again at La Grenouillère, the bathing spot on the Seine where he and Monet had embarked on their new manner of painting more than a decade earlier. As with his outdoor scenes of the mid-1870s, the picture again features several of his friends, including Aline Charigot (1859–1915), the woman who in time would become the mother of his children and eventually his wife. Renoir had enjoyed a number of relationships with women over the previous two decades – among them Lise Tréhot (1848–1922), the model for

In the Summer of 1868 and many other paintings from the late 1860s – but by the early 1880s he seems to have settled quite comfortably into the role of bohemian bachelor.

Renoir in Italy

Aline was a seamstress 18 years Renoir's junior who had moved to Paris with her mother from Essoyes in Burgundy in the east of France. A simple country girl with a modest education, she might have seemed an unlikely match for the bohemian painter, but Renoir had soon realized that, in fact, she embodied everything he was most drawn to in a mate, and in his many paintings of her – such as the radiant portrait of 1885 (*see* pages 16 and 102) – it is plainly evident how much love existed between them. Moreover, as he gradually came to realize, Aline would happily play the supporting role that Renoir needed to help him progress as a

painter. As he admitted to their son Jean after her death, 'She gave me the time to think. She kept an atmosphere of activity around me, exactly suited to my needs and concerns.'

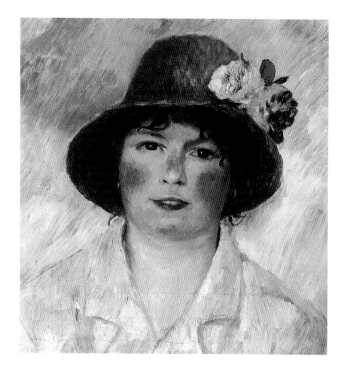

But in the summer of 1881, very early in their relationship, Aline seems to have made it clear that she would not move in with him unless he wanted to have children, and Renoir, even at the age of 40, was not sure he was ready to cross that particular bridge. So with money to spend he set off again, this time on a grand tour of Italy of the kind that young painters were encouraged to make at that time but whose stereotypical character, and thus whose value, Renoir had always dismissed. He soon changed his mind as he travelled down the length of the country, seeing first the Renaissance treasures of Venice, where he painted the city's famous landmarks like so many others before him. But it was when he arrived in Rome and saw the frescoes by Raphael (1483–1520) at the Villa Farnesina that a new way of painting began to suggest itself, an impression that only strengthened as he travelled further south and saw the Pompeian frescoes in the Naples National Archaeological Museum, whose noble simplicity left him deeply moved.

An Anti-Semitic Stain

By early 1882, Renoir had reached Sicily, where one of his idols, the composer Richard Wagner (1813–83), by this time seriously ill, had just completed the score of his final opera, *Parsifal* (1882). In the brief audience he was granted with the titan of German music, Renoir managed to execute a hurried portrait that in Wagner's opinion made him resemble a Protestant minister, the composer peppering his conversation all the while with an effluent stream of anti-Semitic remarks. But Wagner's prejudice, though unashamedly naked in his case, was not unusual for the time among the European elite.

In that regard, sadly, it seems that, despite his son's later refutations and despite the painter's many friendships with Jewish patrons and colleagues such as Pissarro, Renoir himself was prone to a casually expressed anti-Semitism recorded on many occasions by a number of people who knew him. This anti-Semitic undercurrent in French society culminated in the late 1890s in the Dreyfus Affair, and its eventual consequences, long after Renoir's death, would surely have horrified a man who abhorred all violence. Nevertheless, later that year, when he learned that Durand-Ruel planned to submit several of his works to the Seventh Impressionist Exhibition, despite Renoir himself wanting nothing to do with it, the painter expressed himself with unpleasant emphasis: 'The public doesn't like what smells of politics, and as for me, I don't want, at my age, to be a revolutionary. To exhibit with the Jew Pissarro means revolution.'

Parting Company

Renoir had deliberately avoided the fourth, fifth and sixth Impressionist shows, now preferring the Salon even though, after the success of 1879, his paintings were once again hung in places where no one took any notice. But quite apart from the reaction of the critics and the public, Renoir was more and more doubtful about the whole Impressionist project. At their first exhibition in 1874, the critic Jules-Antoine Castagnary (1830–88) had written that, 'Those who in due course have succeeded in perfecting their drawing will leave Impressionism behind, as something which has become too superficial.' It was an opinion with which Renoir found himself increasingly in agreement.

The logical development of Impressionism, as Monet would discover, lay in the dissolution of all forms, which for Renoir represented a kind of 'anarchy', a word he used a lot when denigrating the revolutionary tendencies of friends such as the socialist Pissarro and the Neo-Impressionists with whom Pissarro would soon make common cause. That such a revolution would be likely to invite yet more ridicule from the society on whom he depended for a living, and perhaps also in some measure for self-acceptance, must have made it doubly difficult. As Renoir put it later to Jean: 'The painting of an unknown or little-known man is lost forever because, I repeat, the public knows only a name and a decorated name. The painting of a well-known man is always rediscovered.'

The Crisis of Impressionism

So it was probably a cocktail of understandable mid-life concerns that forced Renoir to rethink his aims and methods at this time, pushing him further in the direction he had already taken with the portraits of the late 1870s. On the one hand, his financial future would remain insecure if he stayed true to the Impressionist creed; and, on the other, he harboured genuine doubts about his legacy, about the longevity of the style – a sense that an art so wedded to the ephemeral and the everyday could not possibly endure beyond its own moment. We can now see that he need not have worried about the future popularity of Impressionism but at the time Renoir was not alone in having such doubts, as both Monet and Pissarro – and before them Cézanne – had come to similar conclusions, though each one responded to the challenge in their own, highly distinctive way.

In the case of Renoir, his new preoccupation with line evident in the portraits of the previous few years became ever more pronounced in his paintings of the early 1880s, bringing discipline to the still high-keyed Impressionist colour of works such as *The Luncheon of the Boating Party* of 1880–81 (*see* below and page 78). Indeed, comparing this picture with *Ball at the Moulin de la Galette* of 1876,

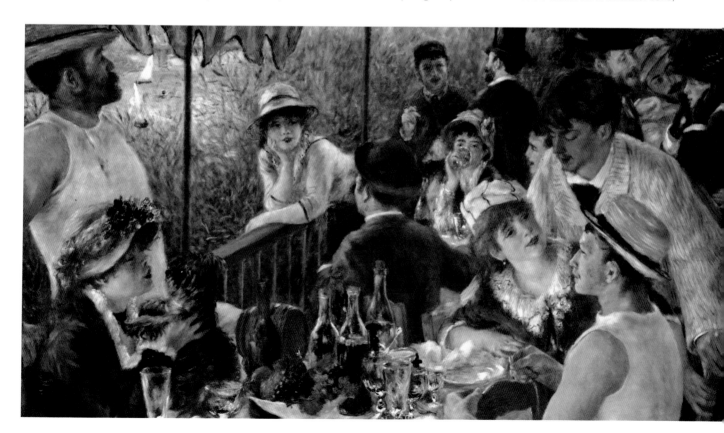

completed a mere five years earlier, shows that his thinking had shifted, an impression evident not only in the greater clarity of line with which the revellers socializing at La Grenouillère are depicted, but in the meticulous detail of the still life – the assorted bottles, plates, wine glasses and bunches of grapes – assembled on the table in the centre of the picture when compared with the far more sketchy treatment of similar foreground objects in the earlier canvas.

Figure and Setting

In fact, Renoir had turned not only to the example of Raphael, which had been such a revelation on his visit to Rome, but also to Jean-Auguste-Dominique Ingres (1780–1867), the painter still held up by the Salon as a paragon of representational virtue, whose Neoclassical legacy the Impressionists had spent so many years trying to escape. So in works such as *By the Seashore* (1883, *see* left and page 91), another picture of his lover, Aline Charigot, Renoir sets a seated figure drawn with almost Classical precision – especially the face – in front of a feathery, chaotic and highly coloured background of what appears to be sky, cliffs and a strand indistinguishable from the sea. While the painting was apparently executed *en plein air* during a trip that he and Aline made to Guernsey in the Channel Islands in the late summer of 1883, the disparity between the clear realization of the figure and the vagueness of the setting makes it seem like a studio picture, as if the carefully executed model had been placed in the usual studio chair in front of a hastily slapped-on theatre backdrop that might be reused for any number of willing subjects.

The Dance Trilogy

If *By the Seashore* is a somewhat under-finished image, the same cannot be said of the three vertical canvases painted earlier that same year which, viewed collectively, constitute perhaps the finest work that Renoir ever painted: the three panels *Dance in the City* (1883, *see* page 94), *Dance in the Country* (1883, *see* pages 20 and 95) and *Dance at Bougival* (1883, *see* page 96). This triptych of modern courtship, a secular altarpiece to Parisian hedonism, transfigures the carefree spirit of the *fête galante* into a timeless celebration of the joyful intimacy of a man and woman dancing. Once again, the models in these paintings are his friends.

Of the women, the model in both *Dance in the City* and *Dance at Bougival* is said to be Suzanne Valadon (1865–1938), at this point in her life a model for Renoir, Pierre Puvis de Chavannes (1824–98) and Henri de Toulouse-Lautrec (1864–1901), among others, but later to become a fine Post-Impressionist painter in her own right; the other model, in *Dance in the Country*, is Aline herself, who according to

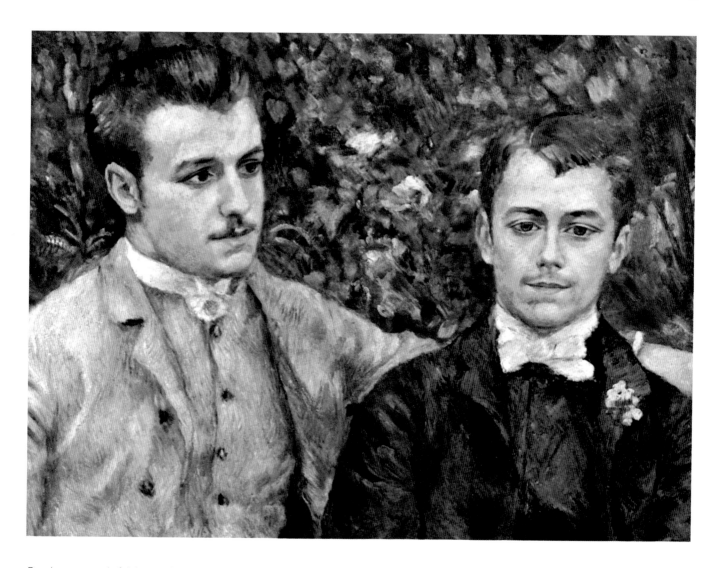

Renoir was a wonderful dancer. As he admitted to Jean in a remark that mentions his friend from La Grenouillère, Baron Raoul Barbier (1852–1908), 'Your mother waltzed divinely. I'm afraid I stepped all over her feet. The star dancer was Barbier. When he started whirling your mother around, everybody stopped to watch them.'

A One-man Show

Two of the canvases, *Dance in the City* and *Dance in the Country*, were exhibited in April 1883 at the one-man show of Renoir's work that Durand-Ruel held in Paris, one of many genuine innovations that the dealer introduced to the repertoire of modern exhibition practice. Following an improvement in the global economic situation in the early 1880s, Durand-Ruel had once again become interested in representing the Impressionists – Monet had been given the first such solo show the previous autumn – and immediately following the Paris show another was held in London. By this time, too, Renoir had also completed a number of portraits over several years of the dealer's many children, the best of which is probably the *Portrait of Charles and Georges Durand-Ruel* (1882, *see* above and page 89), a sensitive image of two youths on the cusp of manhood that we might expect would have filled their father with pride, though apparently the dealer was not too keen.

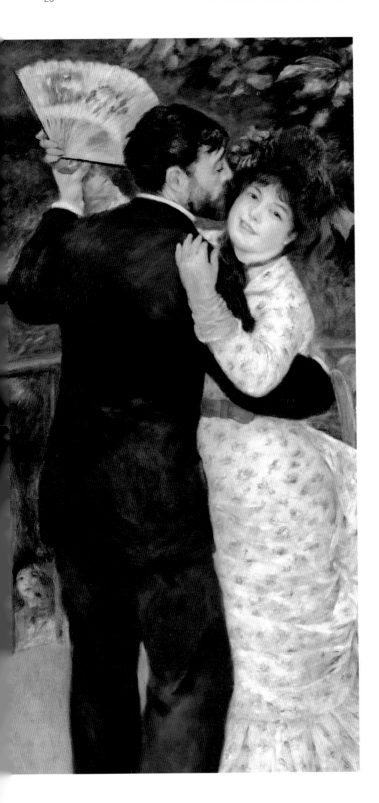

A Difficult Balance

It is hard to believe when looking at pictures such as those of the *Dance* trilogy that Renoir was beginning to experience a crisis in his painting that would get worse before it got better. He was struggling to reconcile the Impressionist style and its commitment to direct apprehension of the subject (and the inevitable formal contingencies that came with it) with his equally strong desire for linear clarity and formal balance. As his son Jean put it, 'he was torn between two procedures: direct perception, on the one hand, and tradition on the other'. To some extent it was a tension Renoir never satisfactorily resolved, and in the mid-1880s it became a demon with which he wrestled, causing him to destroy much of the work he created in those years.

As can be deduced from *By the Seashore*, Renoir was also becoming increasingly frustrated with *plein air* painting, complaining later in life that the constantly changing outdoor light left him unable to correctly judge colour values, so that he compensated by making his pictures darker, only to find when he brought them back to the studio that he had overdone it and was left with gloomy images that bore no resemblance to what he had been trying to convey. Monet faced the same problem during the 1880s and 1890s, but being a committed *plein air* painter, his solution was to paint a series of the same scene in different conditions of light, thereby allowing him to make a virtue of such contingencies. But for Renoir the human figure was paramount in any case, and his struggle throughout the 1880s was to find a way of depicting it that, in his view, as with the work of the old masters, would stand the test of time.

The 'Ingres Period'

The mid-1880s, culminating in *The Large Bathers* (1884–87, *see* page 98) is known as Renoir's 'Ingres Period', on account of the influence of the earlier French master on the works of this time. But despite such a retreat into the certainties of Classicism, it is clear from the variety of approaches he adopted in the works of the mid-1880s how undecided Renoir was about the direction of his art. This is evident in paintings such as the enigmatic portrait of the Bérard children in *Children's Afternoon at Wargemont* (1884, *see* page 99), with its busy profusion of patterned interior surfaces and fabrics and its uncharacteristically

self-absorbed subjects, or the introspective *Girl Braiding Her Hair* (1885, *see* right and page 103), whose Ingres-like clarity of line and air of antique melancholy has more in common with the Pre-Raphaelites than with the Impressionist champions of modern life.

But the new precision in figure drawing that Renoir was slowly acquiring would reach its furthest point of development in the large canvas he had been working on throughout this period, which was not another showpiece of the social life of the *Belle Époque* but a group of nudes in the tradition of the old masters he had studied at the Louvre in his youth, to whose example he had turned once again.

The Large Bathers, a virtuoso exhibition picture of three foreground nudes, awkwardly posed in a landscape with two more figures in the middle distance, was intended as a demonstration of Renoir's new mastery of line and modelling. But its subtitle, 'Attempt at a Decorative Painting', as well as the extreme discontinuity between the Classicism of the figures and the Impressionist setting in which they frolic so self-consciously, hints at the conflicting priorities that Renoir was trying to coalesce, an ambivalence that manifests above all in the rather staged quality of the image. But if the painter himself had been convinced about what he had achieved, the level of dismay of potential patrons, critics, painting colleagues and, indeed, Durand-Ruel when the painting was exhibited in May 1887 – coupled with the poor sale price he achieved for a work that had taken him so long to complete – persuaded him that a re-evaluation was needed.

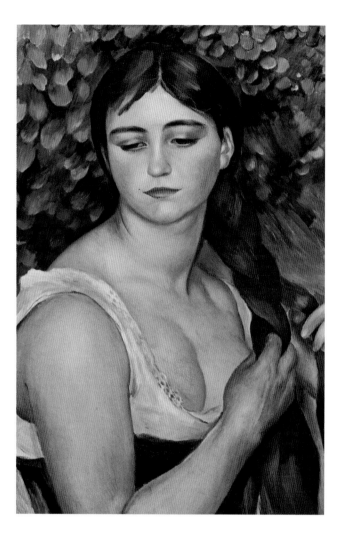

A Family Man

Two years previously, Aline, his cohabiting partner though not yet his wife, had given birth to their first child, Pierre (1885–1952). Renoir executed numerous drawings and paintings of the baby feeding at his mother's breast, as in *Mother and Child, Maternity* (1886, *see* page 104), and there seems little doubt that the grounding of his life that came with being a father had a transformative effect on his art. Within a year of the disappointment of *The Large Bathers*, his style had changed again, and while he did not abandon the nude – indeed, it became central to his output from this point until the end of his life – in works such as *After the Bath* (1888, *see* page 106) an Impressionist softness returns to the figure, who seems far more at one with the setting.

What is new, when compared with the Rococo frivolity of *The Large Bathers*, is the shyness of the downcast gaze and the modesty of the pose. These are qualities seldom in evidence in Renoir's earlier portraits or figure studies, where the gaze of the model or sitter is most often direct and personable, and may even seem to question the viewer, as in *La Loge* (1874, *see* page 46). But in the figure paintings from this time until the end of Renoir's life – whether nudes or genre paintings or, even, portraits – the gaze of the models is often vague and dreamy, echoing the overall treatment of figures and setting. Indeed, even in those portrait sitters or nudes who look directly at the viewer, the eyes are slightly withdrawn, as if neither wanting to know too much about us nor wanting to be probed too deeply themselves.

Success at Last

These works, from the last few years of the 1880s to the end of his life some 30 years later, represent a sea change in Renoir's attitude towards painting whose results, though increasingly admired in their day and for several decades after his death, are now often seen as a strange deviation for an artist who had once been at the forefront of modern art – a retreat into a sentimental worldview that places them outside the mainstream of modern art history. As to why he might have taken this path, several reasons suggest themselves, the first of which being undoubtedly the growth of his family, albeit at long intervals, with the births of first Pierre, then Jean in 1894, and finally Claude in 1901 (d. 1969). But the settled contentment of family life might well have been severely challenged had Renoir's fortunes not taken a sudden turn for the better in the late 1880s.

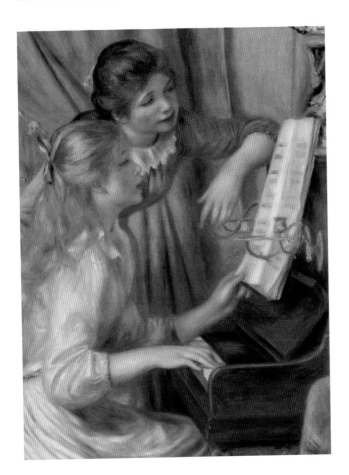

By the middle of the decade, with the world once again in an economic slowdown, Durand-Ruel was as close to financial ruin as some of the painters in whom he had invested so much. In what represented a last throw of the dice, he decided to open a large show of their work in New York in April 1886, in the hope of exciting an art-buying public with plenty of money and few historical hang-ups about what was supposed to be good painting and what was not. The gambit worked better than he could have ever expected, with American buyers immediately falling for this new style of painting, and when a second show in May the following year consolidated this success, not only did prices begin to rise but the public and critics at home began to change their own minds. Suddenly, lasting success seemed likely, and Renoir's income rose exponentially over the next few years, a triumph given an official stamp in 1892 when the French State bought his *Young Girls at the Piano* (1892, *see* left and page 110) for the collection of the Musée du Luxembourg, the first Impressionist painting to be accorded such an honour.

A Debilitating Illness

By this time, another increasingly intrusive influence on the painter's later life was beginning to impinge upon not only his day-to-day activities but, almost certainly, his worldview. Rheumatoid arthritis is a condition that attacks the joints, causing pain, swelling and inhibiting stiffness. It is particularly acute during the kind of flare-up that Renoir first experienced in December 1888, a common occurrence as the disease progresses, and something he would learn to cope with and come back from time and again. Brought on partly by the cold, the attack left him in considerable pain and with a temporary paralysis of his face down one side, and it was not until the following February that he had more or less recovered. But the legacy of each such attack would be a further loss of strength and mobility as well as, most alarmingly, an increasing deformity of his hands.

The Artist's Family

From the outset Renoir seems to have faced his inevitable decline with stoic good humour. The doctors advised him to spend as much of the year as possible in a warmer climate, so from this point in

his life he began staying for long periods in the South of France and making regular visits to Essoyes in the east. In 1890, Renoir and Aline were married, just as Renoir's improving fortunes were beginning to afford them a better standard of life. The genteel domesticity of his new style was proving popular with buyers: genre pictures of women reading or playing the piano with a companion; depictions of his children in costume or, as in *Gabrielle and Jean* (1895–96, *see* right and page 113), playing with their nurse, Aline's much younger cousin Gabrielle Renard (1878–1959). The most ambitious of these family portraits is certainly *The Artist's Family* (1896, *see* page 114), though this picture also points to a continuing tension in Renoir's vision, which is a presence in many of the later works.

On the one hand, Renoir had chosen a recognizable group of people, his own family (including Gabrielle and another young girl, a female neighbour); and on the other, the individuals of which the group is comprised seem without particularity, their faces almost doll-like, as if this were not a specific family but a typical one intended to stand for all families. The painting seems to ape the formal family portraits of the seventeenth and eighteenth centuries, and indeed it has been suggested that Renoir's picture was modelled on *Las Meninas* (*c.* 1656) by Diego Velázquez (1599–1660), which Renoir had seen at the Prado on a visit to Madrid in 1892. It is a bizarre idea, as Renoir was a simple man and *The Artist's Family* has nothing of the ambiguity or mystery of *Las Meninas*. But there is also no sense of the intimate bond that existed between painter and subjects, suggesting that Renoir was caught between past and present: between an ambition to pitch himself grandly into the great tradition of Western painting and a simple desire to paint a picture of the people he loved most in the world.

An Ideal Woman

Certainly, Renoir's preoccupation with the tradition of painting was by now habitual. 'It is in the museum that one learns to paint,' he once said. But his attitude to tradition also revealed aspects of his personality and a vision of the world that would now be regarded as very reactionary. Indeed, his obsession with the nude in the last two decades of his life in paintings such as *Seated Bather in a Landscape*,

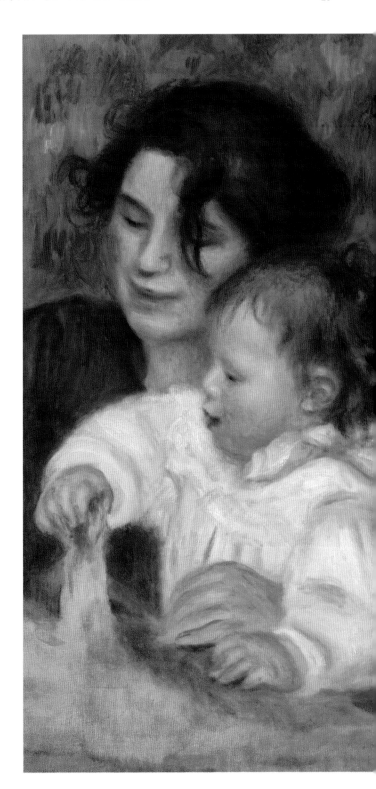

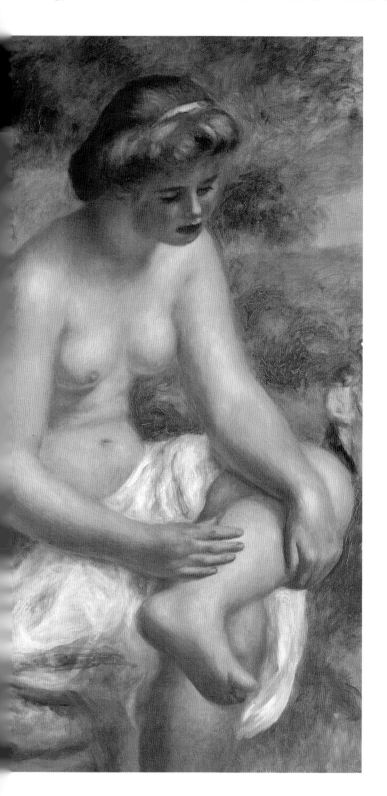

or *Eurydice* (1895–1900, *see* left and page 112) or *Bather* (*c.* 1903, *see* page 118), and in particular the passivity of his sitters, raises the question of exactly what he was trying to communicate in pictures that seem to draw so directly on the mores and values of the past.

In that regard, what mattered to Renoir most about a model was not her personality – as he once put it to Jean, 'Corot's nudes don't think, do they?' – but how her skin took the light. 'What I like is skin,' he said, 'a young girl's skin that is pink and shows she has good circulation.' Such rude good health is certainly in evidence in *Bather*, in the rosy cheeks and the lambent smoothness of the skin, whose range of colour is as great as that of the *c.* 1875–76 *Nude in Sunlight* but now more subtly blended in a way that is indeed reminiscent of the old masters. In this painting, it is clear that he had found a way of uniting the bright Impressionist palette with a style of depiction which had endured for centuries and that was, in Renoir's mind, clearly timeless.

Such a long perspective on the past goes some way to explaining Renoir's conservative sexual politics, as conveyed through his conversations with Jean in seemingly provocative statements such as, 'I like women best when they don't know how to read; and when they wipe their baby's behind themselves,' or, equally, 'Gracefulness is her domain, and even her duty.' Comments such as these could persuade us that the late paintings are in fact deeply conservative exercises in reminding women of their place, and in recent decades they have tended to be seen that way. In denying the women in these paintings the sense of agency he had afforded models such as Lise Tréhot or Nini Lopez (1857–1944), the model who looks at us so enigmatically from the theatre box of *La Loge*, was he simply a foolish fond old man who was physically so frail – unable to walk without crutches by the turn of the century; by 1910 unable even to stand – that everyone was happy to indulge his whims?

La Vie en Rouge

In 1905, after several years of renting houses near the Côte d'Azur, Renoir bought a property known as Les Collettes in Cagnes-sur-mer, close to Nice. There was an existing farmhouse on the site, but by

1907 he was affluent enough, at Aline's insistence, to have a new house built on the substantial plot, including two studios, as well as a further studio built in the grounds. Gradually the warm, bright, roseate light of the south found its way into everything Renoir painted, as his palette gravitated toward the red end of the spectrum, whether in a landscape such as *Terrace in Cagnes* (1905, *see* below and page 119) or an indoor nude such as *Bather* (*c.* 1903). Indeed, ripe reds are a consistent feature (as well as an increasing bias in the skin tone) in the late portraits, such as those of his dealer Paul Durand-Ruel, his wife Aline or the statuesque actress Tilla Durieux (1880–1971). For Renoir, ripeness was all, just as for some, even then, it was all rather too much.

His friend and fellow Impressionist painter Mary Cassatt (1844–1926) spoke of Renoir's late nudes as 'awful pictures' of 'enormously fat red women with very small heads'. And it is true that the bodies of his models, as Renoir depicted them, did become increasingly ample, just as their heads did indeed become smaller in proportion, their facial expressions, as in *After the Bath* (1910, *see* pages 26 and 122), either wistful or dreamy or simply blank. But Cassatt would have known the tradition to which Renoir was looking in these late works, even though as a confirmed Impressionist she did not approve.

Rubens in Munich

In 1910, on his last trip abroad, having recovered from yet another painful arthritis attack that had left him unable to work for months and at a point where, no longer able to walk, he had to be carried everywhere, Renoir travelled to Munich to fulfil several portrait commissions. While

there, he visited the Alte Pinakothek to see the more than 50 paintings by Rubens in that collection. The voluptuous sensuality of Rubens – and also his Venetian progenitor, Titian (c. 1485/90–1576), another profound late influence – were a last great confirmation to Renoir of the justness of the direction in which he was travelling, away from the 'intellectual' tendencies of modern painting – and perhaps also from the crippling limitations of his illness, which left him barely able to hold a brush – towards a generous vision of his faith in life that had been such a fundamental inspiration for Impressionist masterpieces such as *Ball at the Moulin de la Galette* of 1876 and *The Luncheon of the Boating Party* of 1880–81. In the idyll of his life in the south, Renoir now envisioned a timeless Arcadia that stood above the changing fashions of his own age. As he put it to Jean, 'What admirable people the Greeks were. Their existence was so happy that they imagined that the gods came down to earth to find their paradise and make love. Yes, earth was the paradise of the gods. That is what I want to paint.'

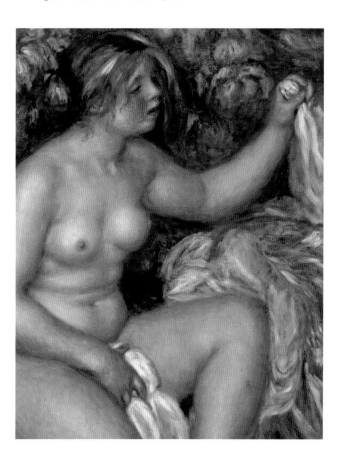

Renoir's Religion

Renoir had always thought of himself as a craftsman, like the painters of the Rococo who had first inspired him. He disliked the word 'artist', which gained increasing currency during his lifetime as a way of describing what he did. But he also realized that mere craft was not sufficient, telling his son that 'whatever the importance of these secondary causes for the decline of our crafts, the chief cause, in my opinion, is the lack of an ideal'. He was not a religious man, but he lamented the loss of religious feeling that he saw as being essential to the creation of great art. 'Religion is everywhere,' he said. 'It is in the mind, in the heart, in the love you put into what you do.' It is a vague idea of what people usually mean by religion; soft around the edges like the forms of the people and objects in his intuitive late works. And, above all, Renoir was a man of intuition, of instinct. He had always avoided theorizing about anything, especially art, preferring to remain silent, even in his early years when the intellectual credos of Impressionism were still being hammered out by his colleagues. Indeed, according to Jean, for his father 'the great dividing line was between those who perceive and those who reason. Having no use for imagination, he allied himself with the world of instinct, as opposed to the world of intelligence.'

A World at War

It is a lovely dream, to live like the animals by instinct alone; but it is not a practical one. In 1914, animal spirits among the governments of Europe led the Continent into war, and Renoir's two eldest sons immediately joined up and, within little more than a month, both had been wounded. Pierre suffered an injury that would invalid him out of the conflict and leave him permanently without the use of his right arm; Jean's wound was fairly superficial and by the spring of 1915 he had returned to the Front, only to be hit again in the thigh, this time more seriously. Aline, obese and diabetic, was no longer well herself, but on receiving news of Jean she travelled north to find that her son's wound had turned gangrenous; only her adamant protests prevented the medics from amputating his leg.

It was a final act of maternal selflessness as, two days later, having returned to Les Collettes, Aline died of a massive heart attack. In the months that followed, Renoir and Jean, struggling to recover from these multiple traumas, sat together in the apartment in the rue

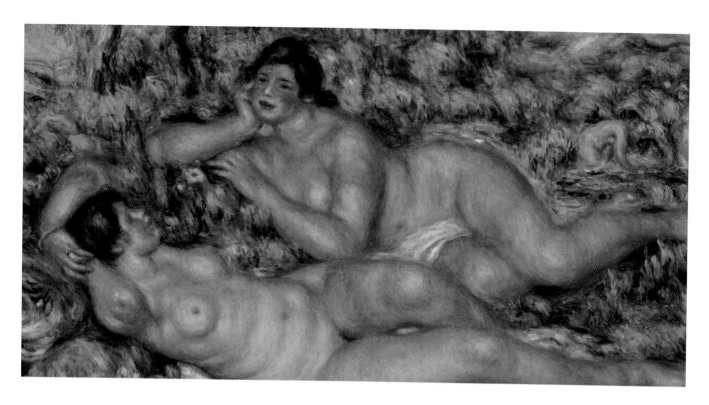

Rochechouart in Paris, travelling back through the painter's life and the life of the nation so vividly described in *Renoir, My Father*. Now barely able to sleep on account of the constant pain, Renoir nonetheless continued to paint, though the brush had to be lodged at the beginning of every session in his gnarled and twisted hands. Incredibly, he was still attempting pictures of huge ambition, above all *The Bathers* (*c.* 1918–19, *see* above and page 125), which features two nudes reclining in a delicately coloured landscape, their skin as subtly responsive to light as anything he had ever painted. Moreover, Renoir felt he was finally achieving the unity of figures and their setting that had eluded him for so long, writing to Durand-Ruel in 1918, 'I'm trying to fuse the landscape with my figures, the old masters never attempted this.' Although it is some claim, clearly his ambition was undimmed.

Among the Immortals

Of course, his idea of a paradise on earth seems like pure escapism in the context of a world war that had brought suffering to Renoir's own family, as it had to so many others. But that was the point. The depiction of such an ideal world had a long tradition in art, which for Renoir was precisely what the modern world, with its machinery of mass production and destruction, had quite disastrously forgotten. Renoir died on 3 December 1919, having lived to see one of his own paintings, a portrait *Mme Georges Charpentier* (1876–77), hung in the Louvre. He was buried beside Aline in the graveyard in Essoyes. Having been regarded in his final years as 'the greatest living painter', he was also widely mourned. His reputation continued to rise, with the late nudes acting as an inspiration to Pablo Picasso (1881–1973) during his 'Neoclassical' period of the early 1920s, as well as to younger French artists such as Pierre Bonnard (1867–1947) and Henri Matisse (1869–1954). If the status of the late works has declined since the Second World War, Renoir would probably have greeted such vicissitudes with a wry smile; as he aged, he took the long view. As a young man, he had painted unforgettable images of the social life of his time, panegyrics to the fleeting pleasures of the *Belle Époque*. But in old age he sought the essence of that pleasure in the work of the old masters who had enraptured him as a youth, in the pantheon of immortals among whom he trusted he would one day find a place.

Towards Impressionism

In his early career, Renoir went from being a Realist to being even more of one: the primary impulse of Impressionism was to depict real life as lived by real people according to the painter's real experience of them.

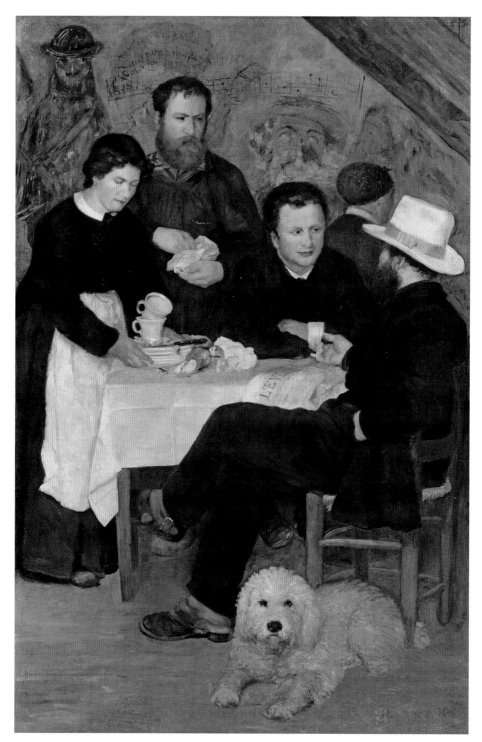

Mother Anthony's Tavern, 1866
Oil on canvas, 194 x 131 cm (76¼ x 51½ in)
• Nationalmuseum, Stockholm

This painting features three friends of Renoir's at a favourite inn near Fontainebleau: Claude Monet, his early patron Jules Le Coeur (1832–82) and Alfred Sisley. Mère Anthony can be seen behind them with her back turned.

Portrait of Lise, 1867
Oil on canvas, 182 x 118 cm (71³/₄ x 46¹/₂ in)
• Museum Folkwang, Essen

This large portrait of Renoir's lover, Lise Tréhot, was painted in the forest of Fontainebleau and exhibited at the Paris Salon in 1868. Lise remained Renoir's muse for several years until the couple drifted apart.

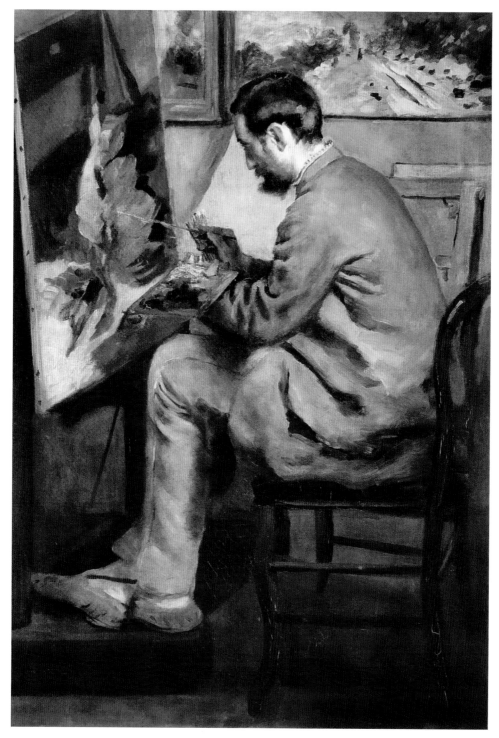

Frédéric Bazille at his Easel, 1867
Oil on canvas, 105 x 73.5 cm (41¼ x 29 in)
• Musée d'Orsay, Paris

Frédéric Bazille is the great what-might-have-been of Impressionism. A hugely talented painter, he was also generous with his inherited wealth, at one point in the 1860s inviting Renoir to share his studio when the latter was broke.

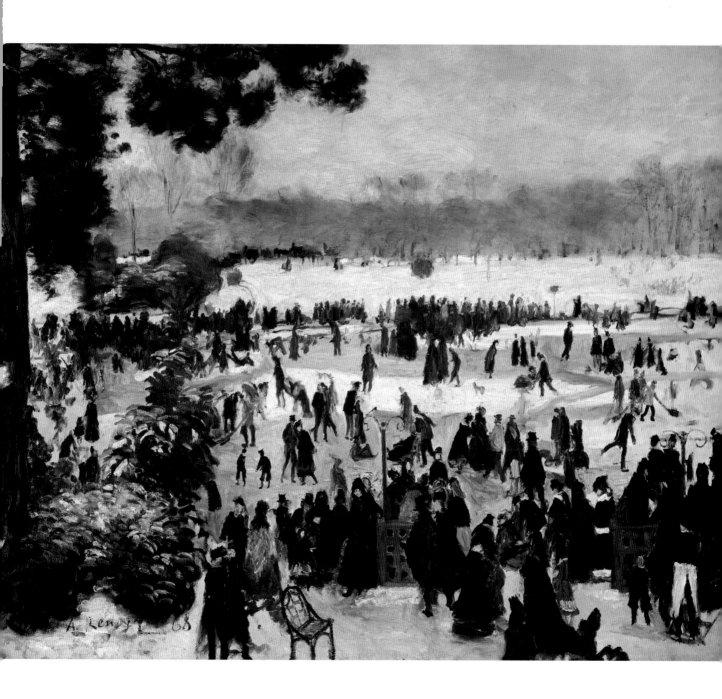

Skaters on the Bois de Boulogne, 1868
Oil on canvas, 72.1 x 89.9 cm (28½ x 35½ in)
• Private Collection

Renoir's later penchant for festive social scenes is clearly evident in this winter canvas.
The Impressionists' interest in the social life of the ordinary citizen represented one of
many breaks with the painting conventions of the Salon.

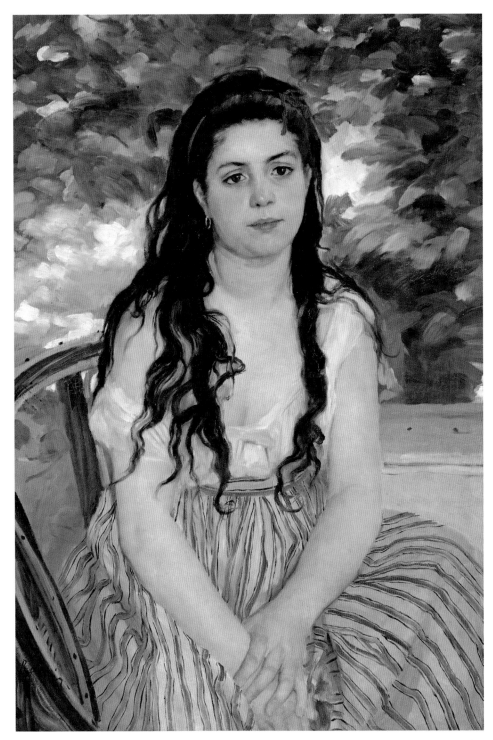

In the Summer, 1868
Oil on canvas, 85 x 59 cm (33$\frac{1}{2}$ x 23$\frac{1}{4}$ in)
• Alte Nationalgalerie, Berlin

The model for this painting was Lise Tréhot, in this case dressed as a 'gypsy'.
A substantial portrait of a working-class girl was an unusual subject for the time.

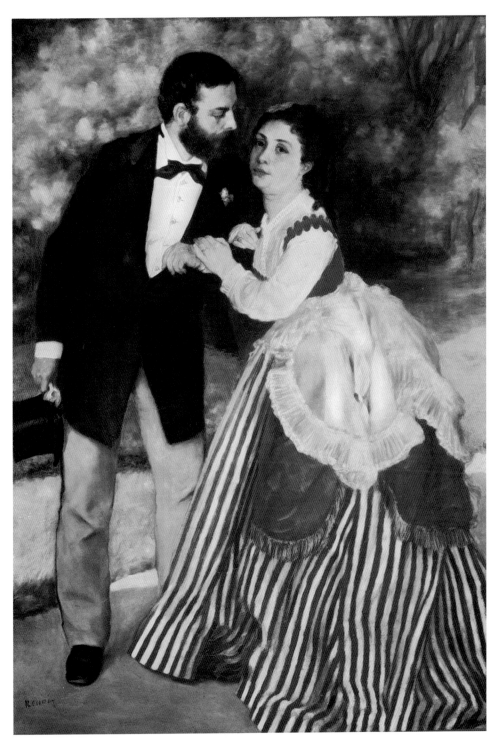

The Engaged Couple, or The Sisley Family, 1868
Oil on canvas, 105 x 75 cm (49¼ x 29½ in)
• Wallraf-Richartz Museum, Cologne

This painting is not what it seems, which may explain the couple's apparent awkwardness. Although the man is indeed Renoir's fellow Impressionist Alfred Sisley, the woman is not his wife-to-be but Renoir's favourite model of the time, Lise Tréhot.

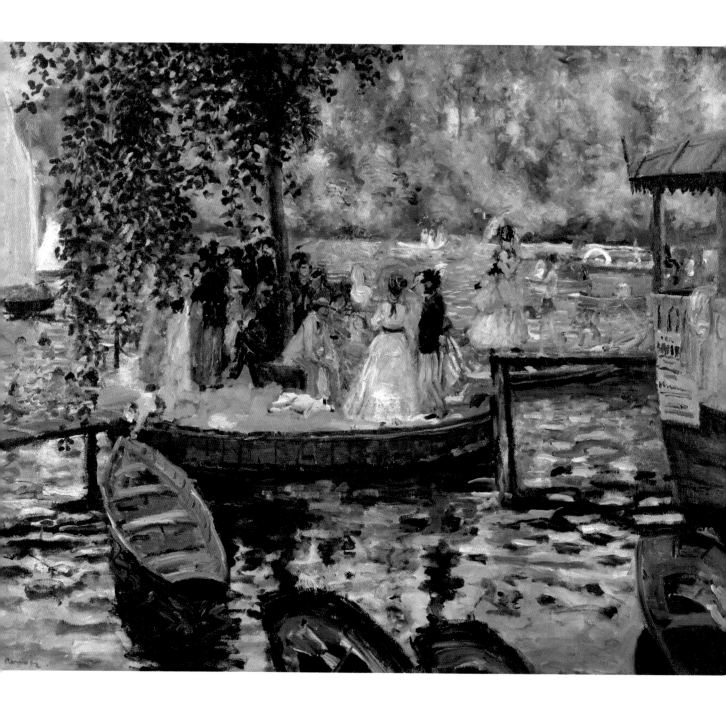

La Grenouillère, 1869
Oil on canvas, 66.5 x 81 cm (26 x 32 in)
• Nationalmuseum, Stockholm

La Grenouillère, a fashionable watering hole near Chatou, on the Seine, was the place where Impressionism was born. The name, which translates as 'The Frog Pond', refers to the kind of free-spirited women who liked to socialize there.

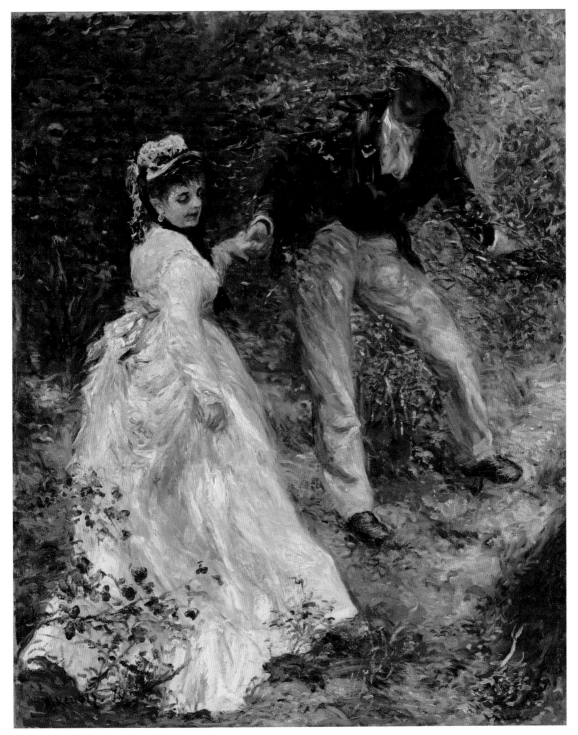

The Promenade, 1870
Oil on canvas, 81.3 x 64.8 cm (32 x 25½ in)
• The J. Paul Getty Museum, Los Angeles

In this early Impressionist work, the agitated brushwork with which both the figures and their surroundings are depicted seems to perfectly express the nervous excitement we assume they must be feeling.

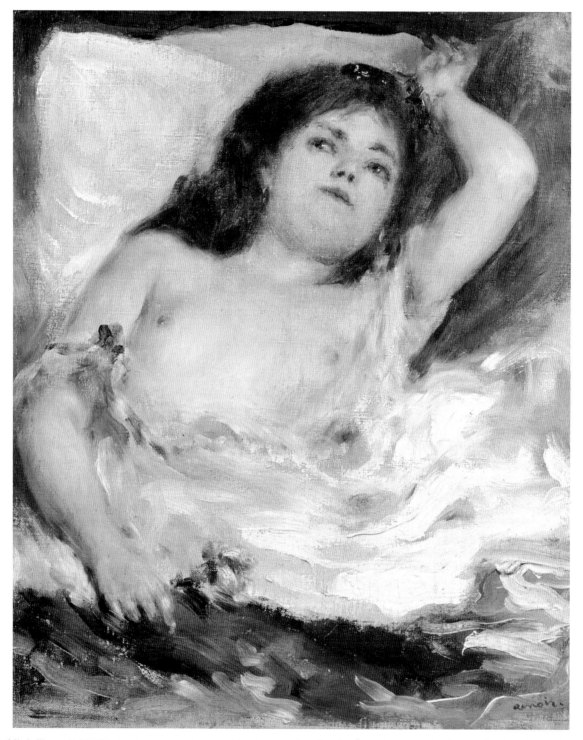

Semi-Nude Woman in Bed (The Rose), before 1872
Oil on canvas, 29.5 x 25 cm (11$\frac{1}{2}$ x 9$\frac{3}{4}$ in)
• Musée d'Orsay, Paris

This moody and highly erotic painting depicts a subject that the older Renoir would never have painted in quite this way. The troubled look in the woman's eyes makes us wonder about the relationship between painter and model.

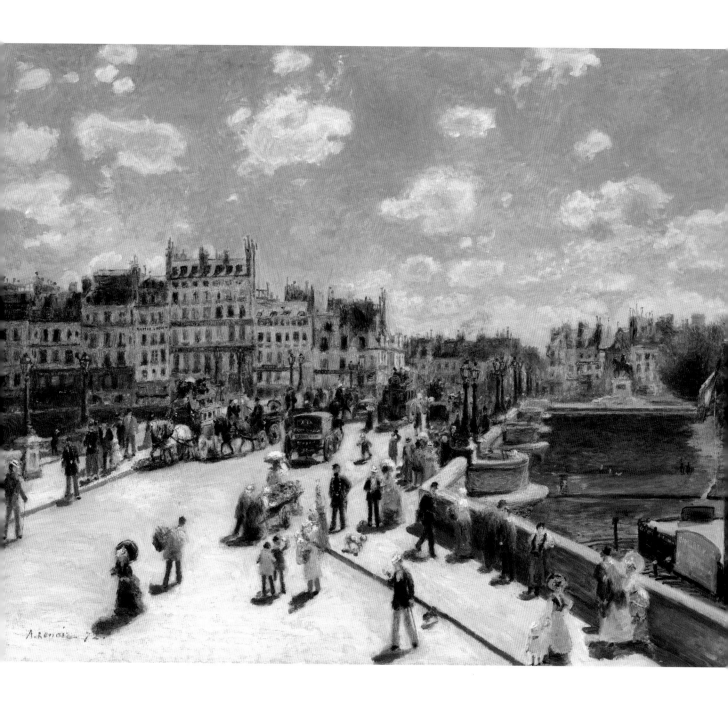

Pont Neuf, Paris, 1872
Oil on canvas, 75.3 x 93.7 cm (29¾ x 37 in)
• National Gallery of Art, Washington, DC

The optimistic activity of the modern city is a typical Impressionist subject, and Renoir was as drawn to such scenes as colleagues such as Monet and Pissarro. In this painting, Paris is a cheerful playground for a pleasure-seeking middle class.

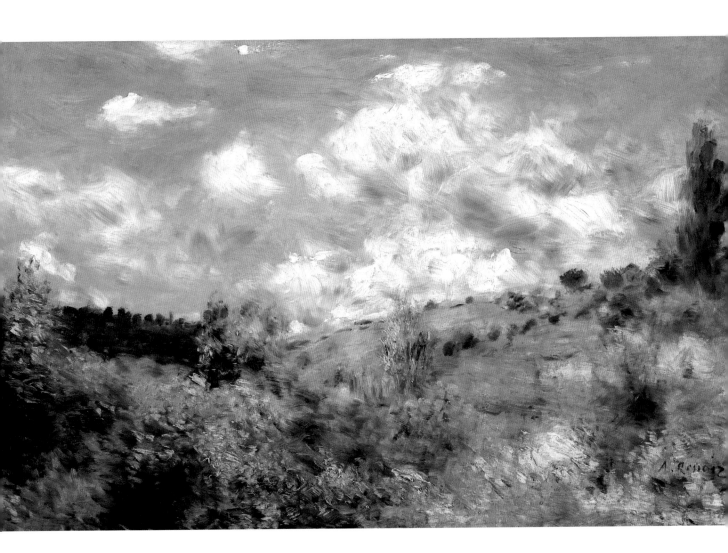

The Gust of Wind, *c.* 1872
Oil on canvas, 52 x 82.5 cm (20^1/$_2$ x 32^1/$_2$ in)
• Fitzwilliam Museum, Cambridge

This landscape study superbly captures something invisible and utterly ephemeral. Using a muted palette reminiscent of that of Jean-Baptiste-Camille Corot, its ineffable sense of movement brings to mind the cloud studies of John Constable (1776–1837), by whom Corot was inspired.

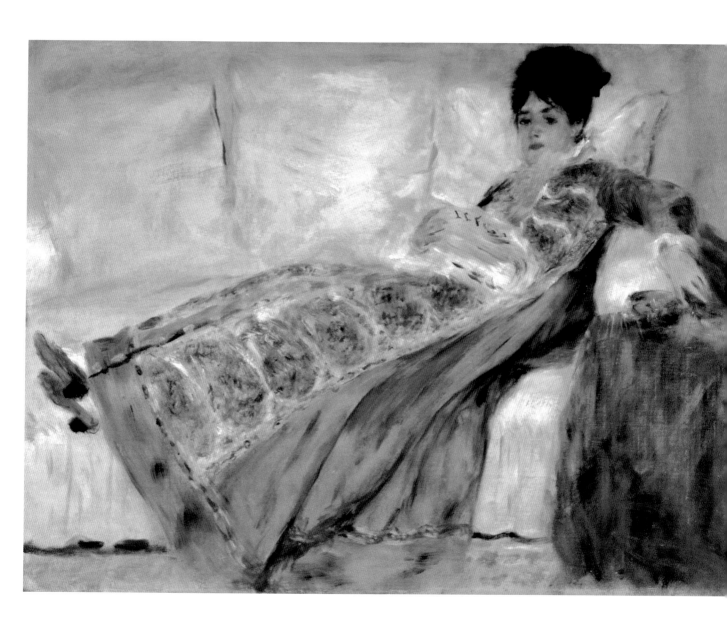

Madame Monet Reading *Le Figaro*, 1872
Oil on canvas, 54 x 72 cm (21¼ x 28¼ in)
• Museu Calouste Gulbenkian, Lisbon

When first exhibited, this portrait of Monet's wife, Camille Doncieux (1847–79), was attacked by a reactionary critic, disturbed by the absence of modelling in the figure, whose dress seems to flatten her against the couch on which she lies.

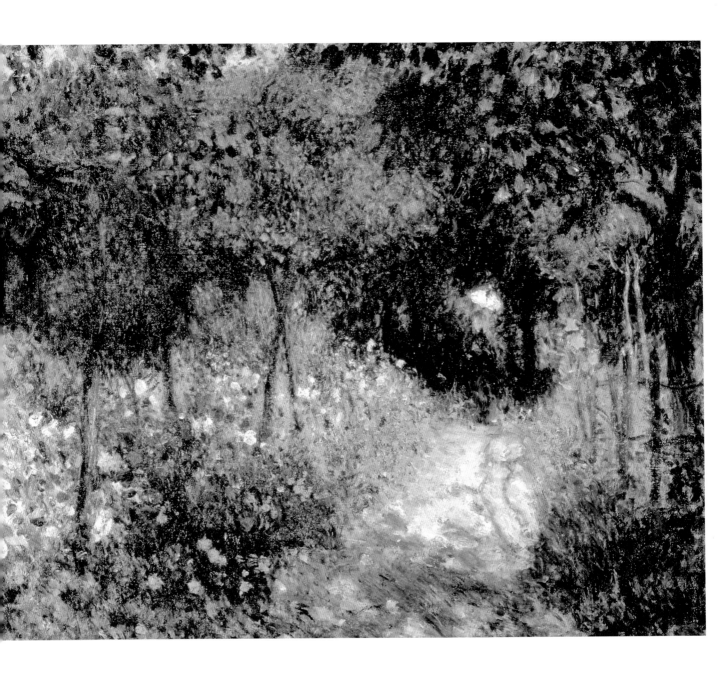

Woman in a Garden, 1873
Oil on canvas, 54.6 x 65.4 cm (21½ x 25¾ in)
• Private Collection

In this magical image, the woman is almost an incidental presence, subsumed into the prevailing atmosphere of coloured flowers despite being the supposed subject of the painting. Even the parasol she is holding might be nothing more than another bloom.

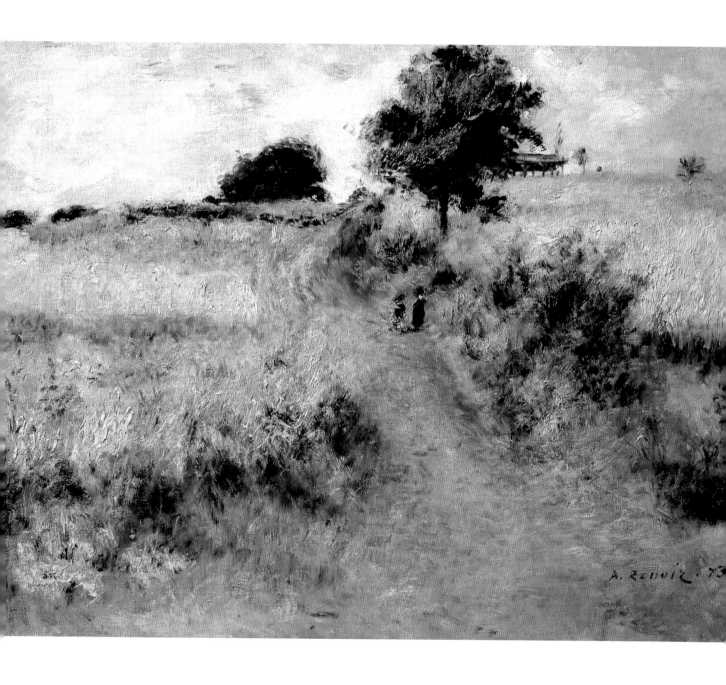

The Watering Place, 1873
Oil on canvas, 47 x 61 cm (18$\frac{1}{2}$ x 24 in)
• Private Collection

The muted palette of this image suggests the influence of the Barbizon school of landscape artists, in particular Jean-Baptiste-Camille Corot, whom all the Impressionists, and especially Renoir, greatly admired.

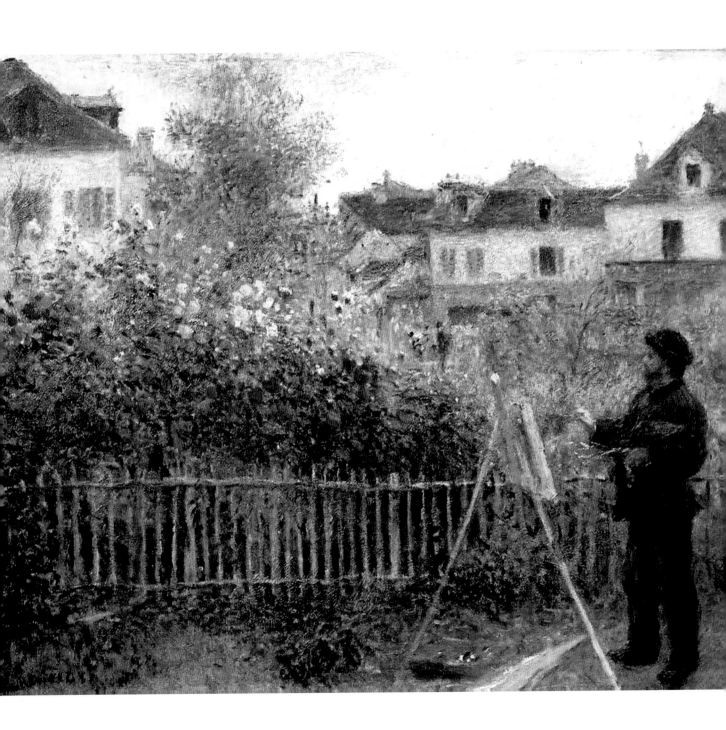

Monet Painting in his Garden at Argenteuil, 1873
Oil on canvas, 46 x 60 cm (18 x 23½ in)
• Wadsworth Atheneum Museum of Art, Hartford

When Renoir's friend Claude Monet painted his garden in the town of Argenteuil, he sought to portray it as a rural retreat rather than the suburban residence it was. Renoir's more topographically accurate painting betrays an artist with different priorities.

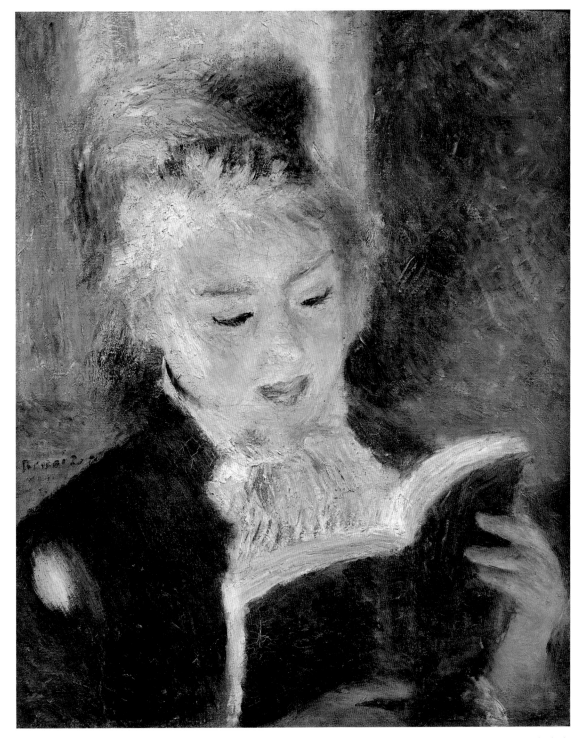

Girl Reading, 1874
Oil on canvas, 46.5 x 38.5 cm (18¼ x 15¼ in)
• Musée d'Orsay, Paris

A favourite subject for Renoir throughout his life, the face of this girl, despite being in shadow, seems to be literally illuminated by the contents of her book. Renoir later said he did not like women to read; looking at this image, you would not have thought so.

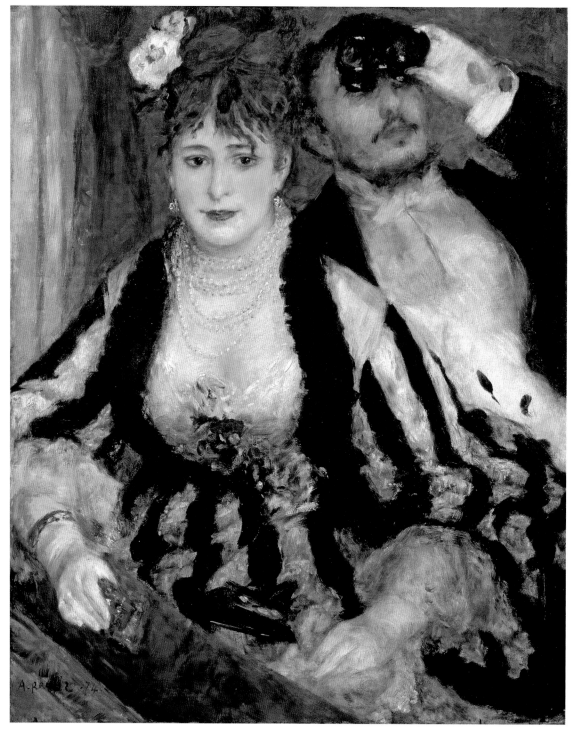

La Loge, 1874
Oil on canvas, 80 x 63 cm (31$\frac{1}{2}$ x 24$\frac{3}{4}$ in)
• The Courtauld Gallery, London

This famous image is among the most ambiguous Renoir ever painted. Who is this handsome woman who looks at us so directly and yet so enigmatically? What is she trying to tell us with that gaze?

The Dancer, 1874
Oil on canvas, 142.5 x 94.5 cm (56 x 37¼ in)
• National Gallery of Art, Washington, DC

This sweet, almost sentimental image was roundly attacked by the critic Louis Leroy, who described the dancer's legs as being 'as cottony as the gauze of her skirts'. He was correct in his impression, but then so was the painter.

A Painter in Ordinary

Faced with a hostile press and a public largely indifferent to Impressionism, in the mid to late 1870s Renoir came to depend on portrait commissions to keep the wolf from the door and to fund his more ambitious paintings.

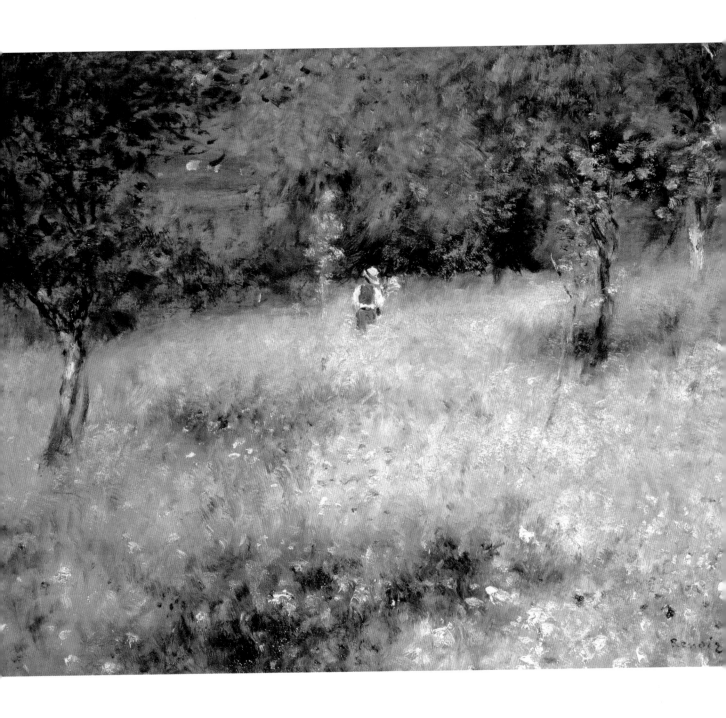

Spring at Chatou, c. 1872–75
Oil on canvas, 23 x 29 cm (9 x 11½ in)
• Private Collection

This is another landscape image strongly influenced by Corot. The field of flowers is not so much the customary carpet of Impressionist colour but a verdant cloud of foliage that was Corot's signature treatment.

**Woman with a Parasol and Small Child
on a Sunlit Hillside, c. 1874–76**
Oil on canvas, 47 x 56.2 cm (18^1/$_2$ x 22 in)
• Museum of Fine Arts, Boston

Even the most accidental of photographs taken on a long exposure would struggle to capture
the sense of a fleeting moment that Renoir has managed to convey in this vivid scene.

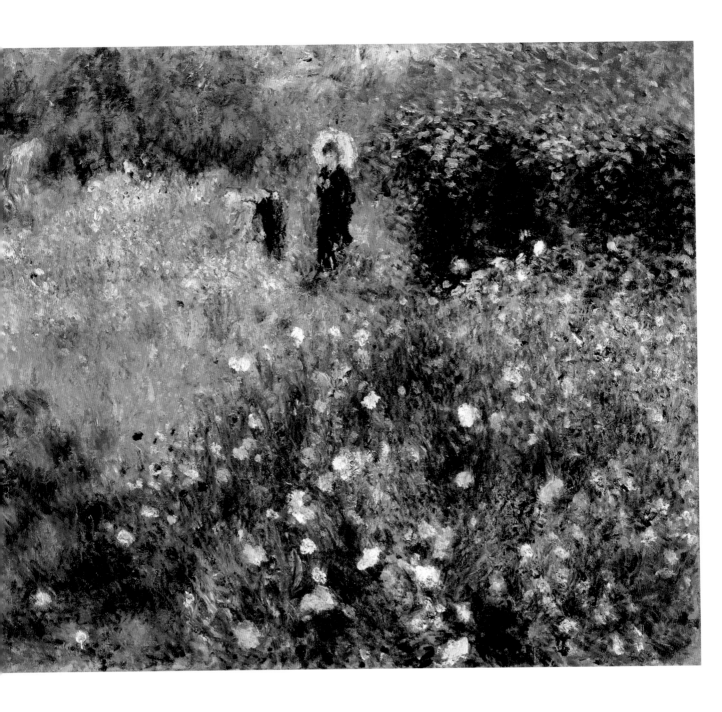

Woman with a Parasol in a Garden, 1875
Oil on canvas, 54.5 x 65 cm (21¹/₂ x 25¹/₂ in)
• Museo Thyssen-Bornemisza, Madrid

With a sea of flowers in such apparently chaotic profusion – despite the presence of a gardener bending over – we suspect that we have stumbled on an uncultivated wilderness. Such disorder was central to how the Impressionists saw the world.

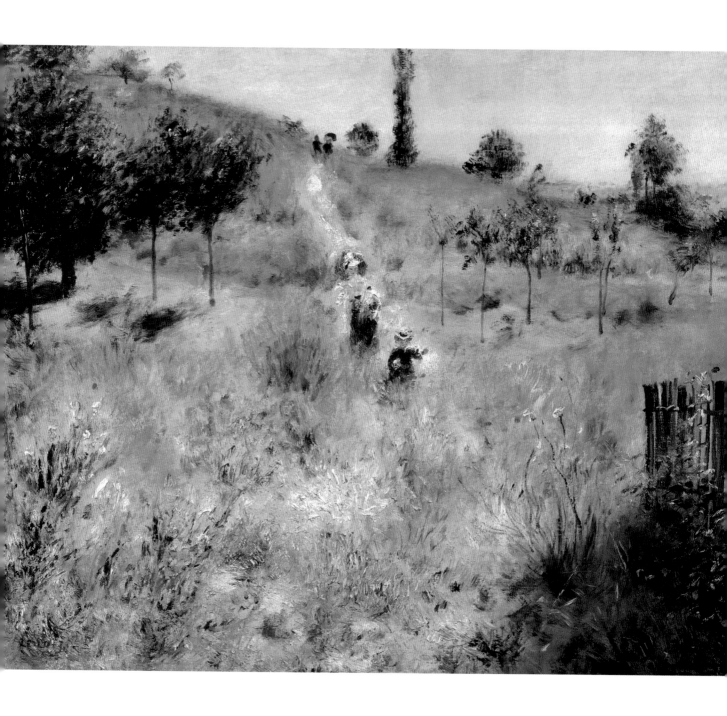

The Path through the Long Grass, *c.* **1875**
Oil on canvas, 60 x 74 cm (23½ x 29¼ in)
• Musée d'Orsay, Paris

The path through the field is a classic Impressionist landscape subject. The people heading towards us seem enveloped in the contentment of their environment. The painting tries to persuade us that life does not get any better than this.

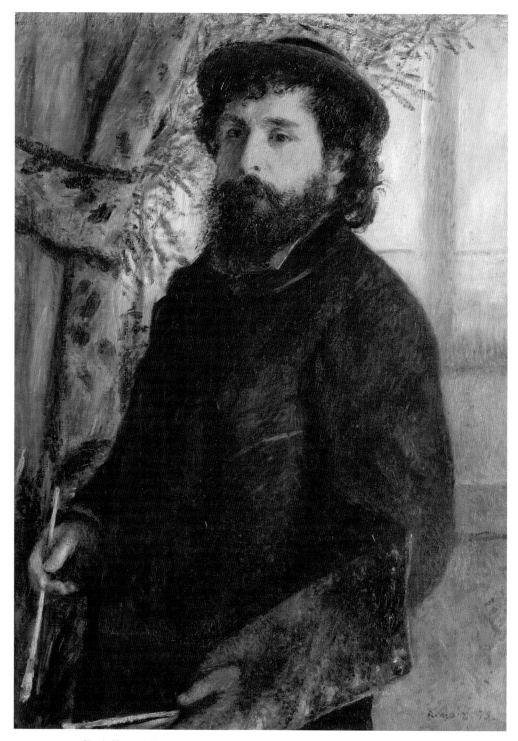

Claude Monet, 1875

Oil on canvas, 85 x 60 cm (33$^{1}/_{2}$ x 23$^{1}/_{2}$ in)

• Musée d'Orsay, Paris

What a vivid portrait of the 'lordly' Claude Monet, as one friend described him. With his head slightly tilted back, he seems utterly convinced of his talent as a painter and of his worth as a man.

Self-Portrait, c. 1875
Oil on canvas, 39.1 x 31.8 cm (15½ x 12½ in)
• The Clark Art Institute, Williamstown

Some of those who knew Renoir as a young man described him as ill at ease in company, full of nervous tics and generally lacking in social graces. This rather haunted self-portrait suggests as much.

Portrait of Victor Chocquet, *c.* 1875
Oil on canvas, 53 x 43.5 cm (20³/₄ x 17 in)
• Fogg Art Museum, Harvard Art Museums

Late in life, Renoir compared Victor Chocquet, one of the Impressionists' most committed early patrons, to the Renaissance popes. In this portrait, he makes a charming and very informal pope.

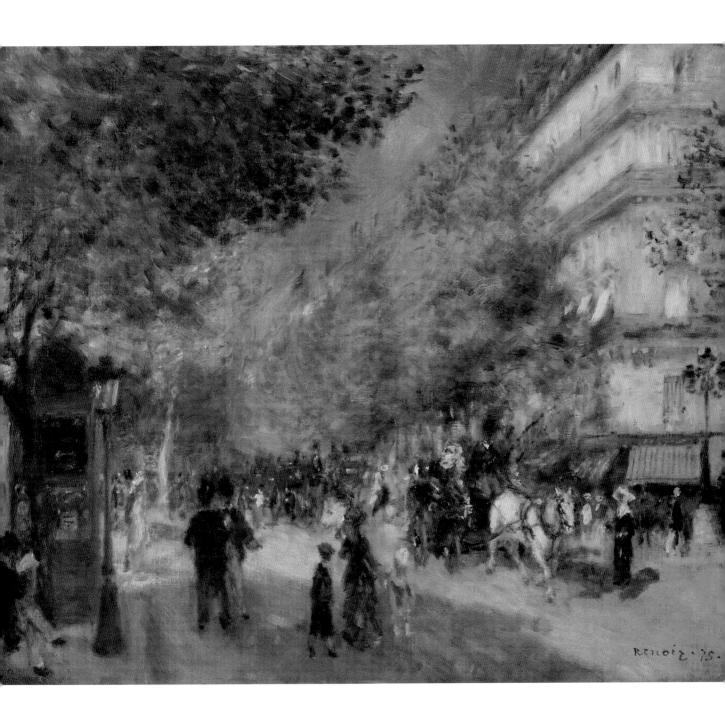

The Grands Boulevards, 1875
Oil on canvas, 52.1 x 63.5 cm (20½ x 25 in)
• Philadelphia Museum of Art, Philadelphia

This painting demonstrates why the Impressionist technique was so well attuned to conveying the hubbub of hectic modern life. Nothing is still, everything is animated: the people, the trees, even the buildings that line the road.

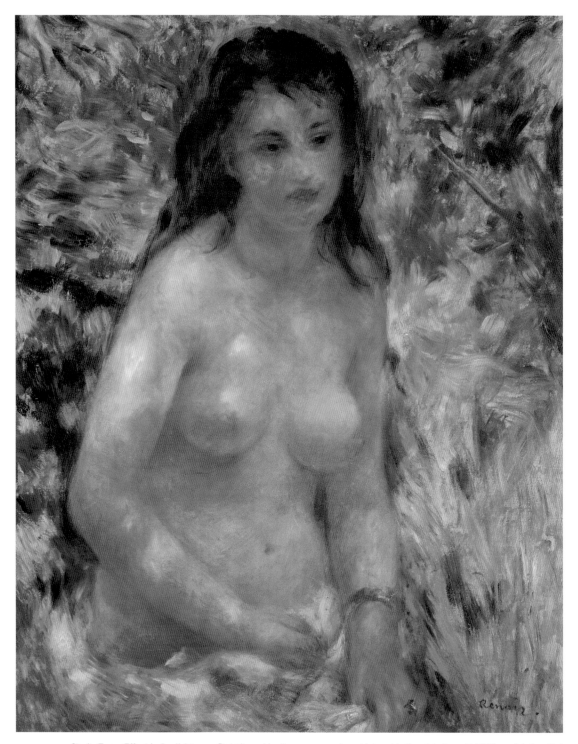

**Study, Torso, Effect in Sunlight
(Nude in Sunlight),** *c.* **1875–76**
Oil on canvas, 81 x 65 cm (32 x 25$^{1}/_{2}$ in) • Musée d'Orsay, Paris

Portraits and landscapes were of most interest to Renoir in the mid-1870s, so it is hard to know what persuaded him to paint this visionary masterpiece of hallowed light. Needless to say, it was ridiculed by critics when first exhibited.

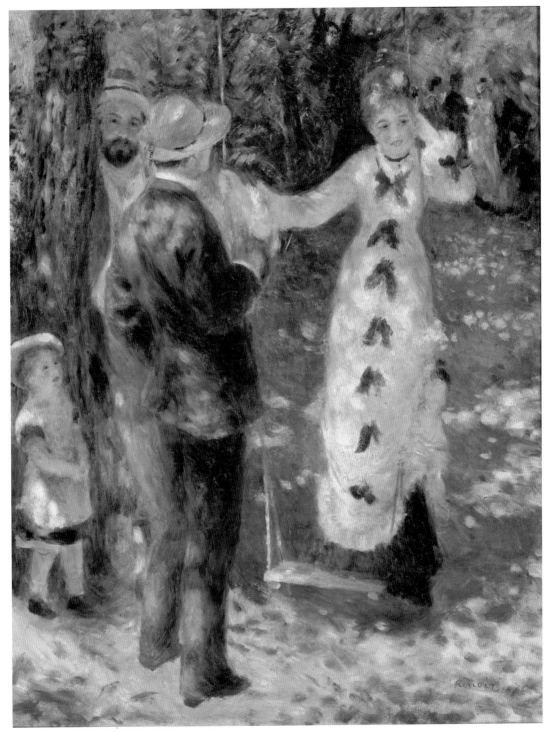

The Swing, 1876
Oil on canvas, 92 x 73 cm (36¹/₄ x 28³/₄ in)
• Musée d'Orsay, Paris

With a nod to Rococo painters such as Jean-Honoré Fragonard, this painting makes us wonder what the gentleman with his back to us must have said to the woman that she has so clearly succumbed to reverie.

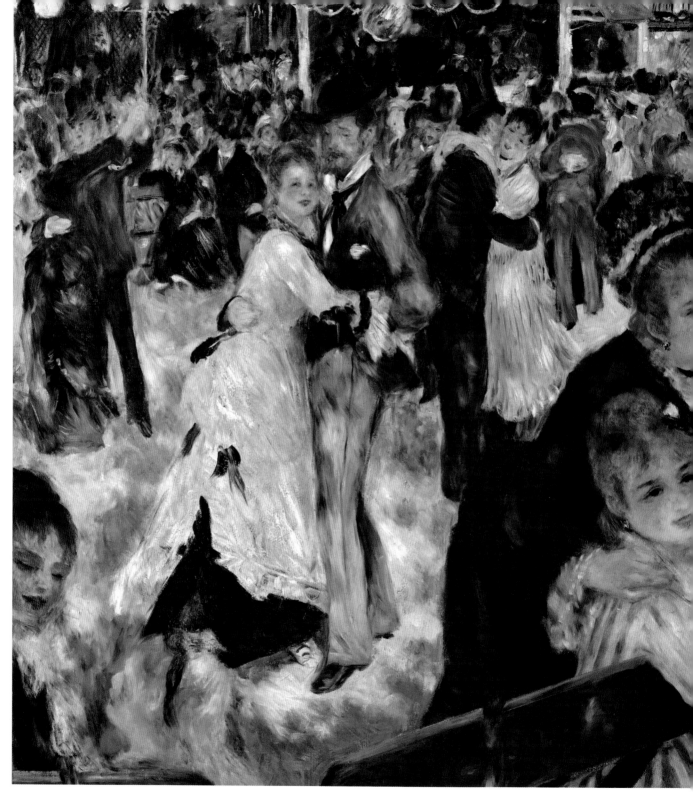

Ball at the Moulin de la Galette, 1876
Oil on canvas, 131 x 175 cm (51$\frac{1}{2}$ x 69 in) • Musée d'Orsay, Paris

An undisputed masterpiece of Impressionist colour and light, in this painting the gazes of Renoir's dreamlike models have a blissful quality that became the prevailing mood of his later work.

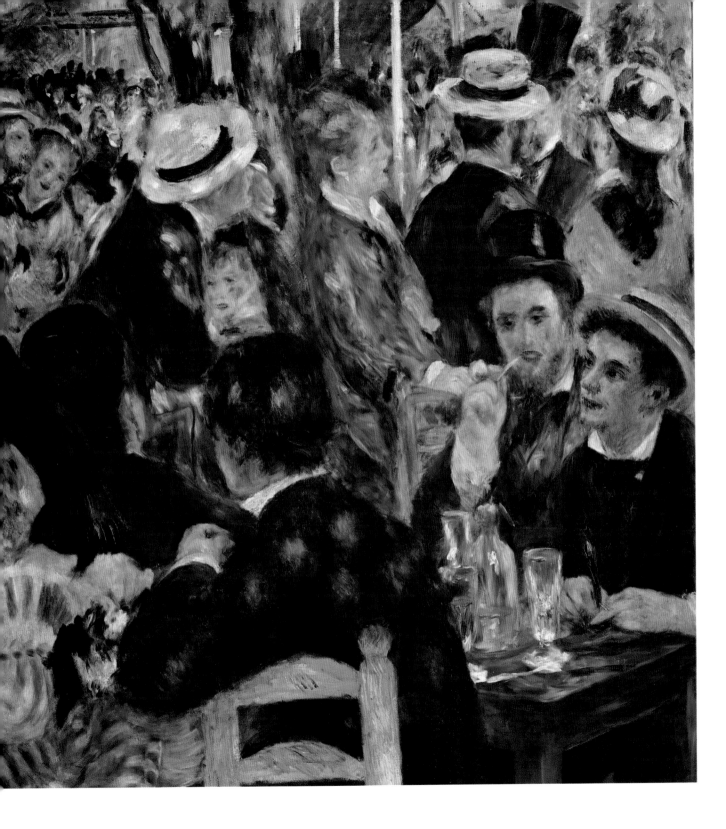

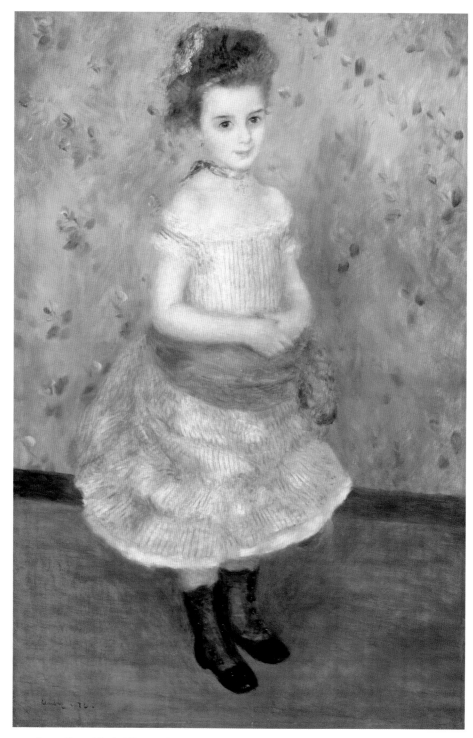

Jeanne Durand-Ruel, 1876
Oil on canvas, 113 x 74 cm (44^1/$_2$ x 29^1/$_4$ in)
• The Barnes Foundation, Philadelphia

In this portrait of the young daughter of Renoir's dealer, the contrast between the prim finery of the dress and the position of the hands, and the childhood vulnerability of the face, makes for a curious social comedy.

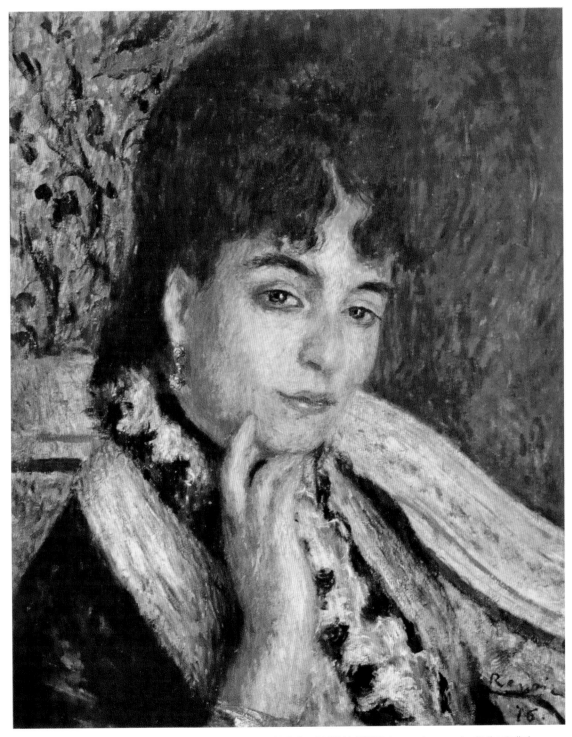

Portrait of Madame Alphonse Daudet, 1876
Oil on canvas, 46 x 38 cm (18 x 15 in)
• Musée d'Orsay, Paris

This portrait of Julia Daudet (1844–1940) is immensely warm, despite the studied sophistication of the pose. The wife of the novelist Alphonse Daudet (1840–97), she was herself a well-known poet and journalist.

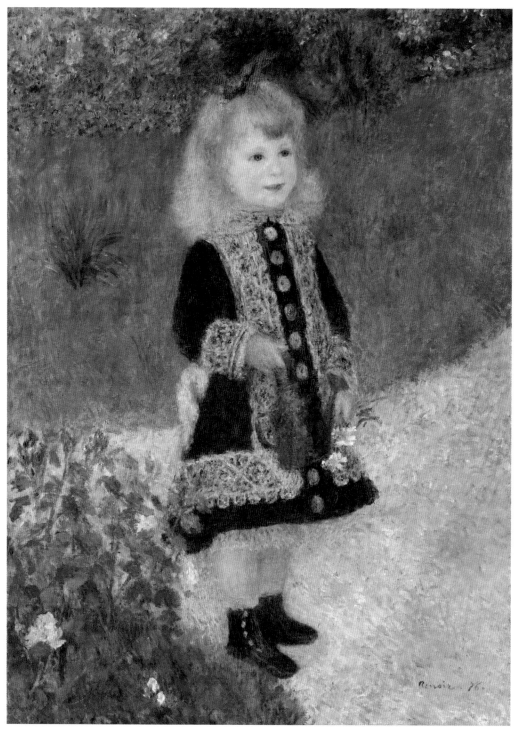

A Girl with a Watering Can, 1876
Oil on canvas, 100 x 73 cm (39¹/₂ x 28³/₄ in)
• National Gallery of Art, Washington, DC

This portrait of one Mademoiselle Leclère is another of Renoir's many charming depictions of children. Here the girl seems to have been interrupted in her game by someone, perhaps a parent, calling to her from a little way off.

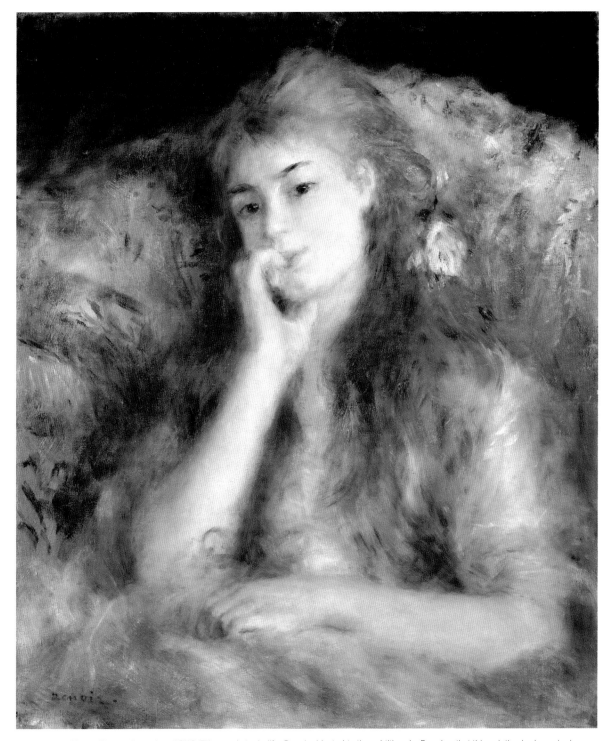

Young Woman Seated, *c.* 1876–77
Oil on canvas, 66 x 55.5 cm (26 x 21³/₄ in)
• The Barber Institute of Fine Arts, Birmingham

Later in life, Renoir objected to the subtitle – *La Pensée* – that this painting had acquired since he'd painted it. But while he insisted that: 'My models don't think at all,' in this canvas his brush tells a different story.

At the Theatre (La Première Sortie), 1876–77
Oil on canvas, 65 x 49.5 cm (25$^{1}/_{2}$ x 19$^{1}/_{2}$ in)
• National Gallery, London

The position of the painter is crucial to the effect of this picture of a young woman on her first outing to the theatre. We sense her eager anticipation in the slowly filling auditorium visible to her right.

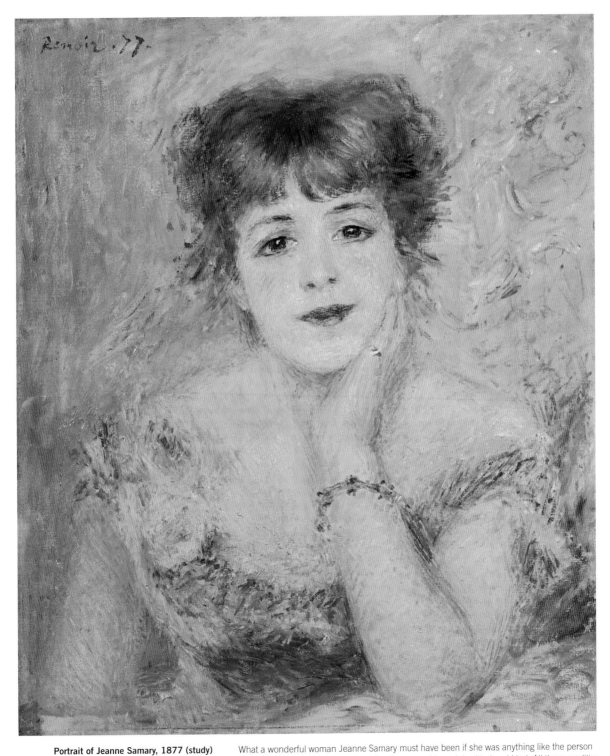

Portrait of Jeanne Samary, 1877 (study)
Oil on canvas, 56 x 47 cm (22 x 18½ in)
• The Pushkin State Museum of Fine Arts, Moscow

What a wonderful woman Jeanne Samary must have been if she was anything like the person in this vivid portrait: eager, curious, frank, personable, quick-witted and kind. All these qualities and numerous others erupt from this marvellous work.

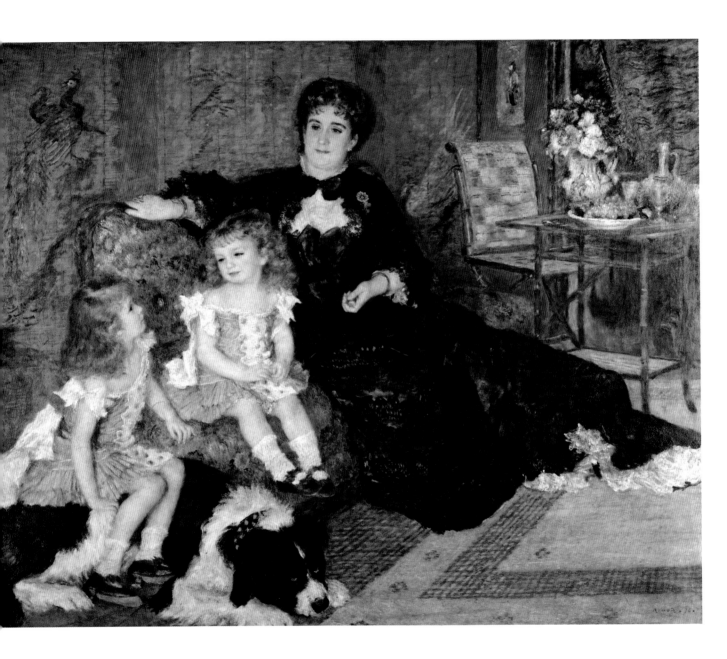

Madame Charpentier and Her Children, 1878
Oil on canvas, 153.7 x 190.2 cm (60½ x 75 in)
• Metropolitan Museum of Art, New York

This dignified canvas of a woman and her children is enriched in colour and social sophistication by the opulent background betraying many influences. It is a subtle portrayal of a woman both at ease in Parisian society and keen to look beyond it.

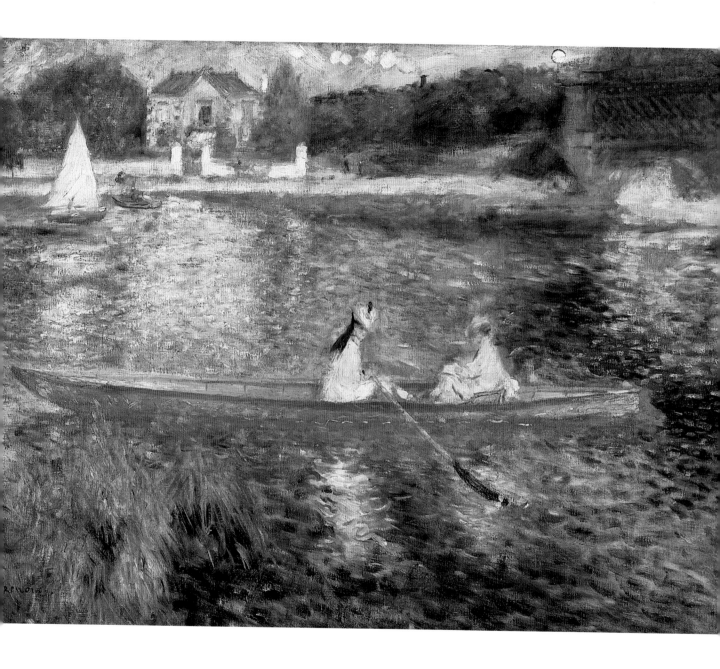

**Boating on the Seine, or The Skiff,
or The Seine at Asnières, c. 1879**
Oil on canvas, 92 x 71 cm (36¼ x 28 in) • National Gallery, London

Boating was a favourite leisure activity of the Parisian middle class. Scenes such as this one were a favourite subject for the Impressionists, affording them ample opportunity for creating complex tapestries of colour through light reflected on water.

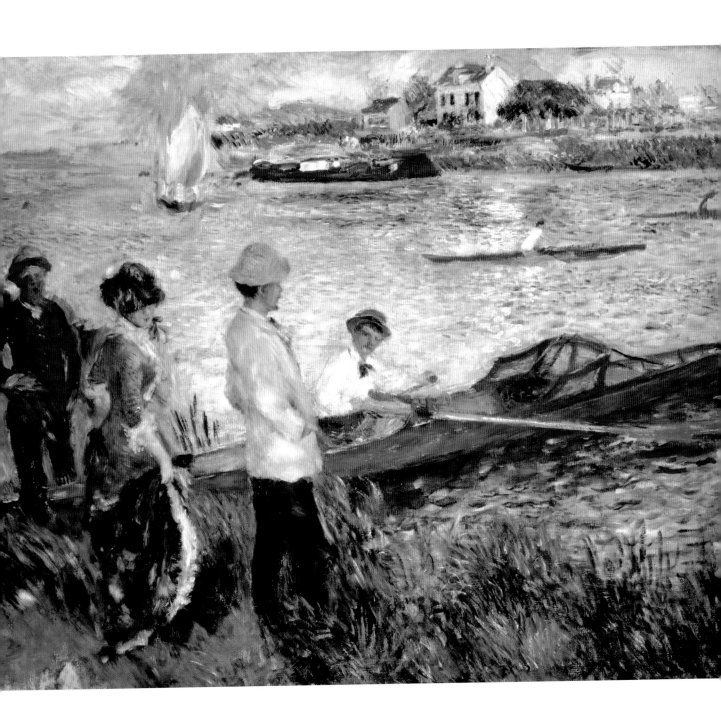

Oarsmen at Chatou, 1879
Oil on canvas, 81.2 x 100.2 cm (32 x 39½ in)
• National Gallery of Art, Washington, DC

Chatou was a favourite destination for Parisians heading out of the city for a little leisure and relaxation. The informality of the people in this painting is underscored by the sheer variety of colour reflected in the water.

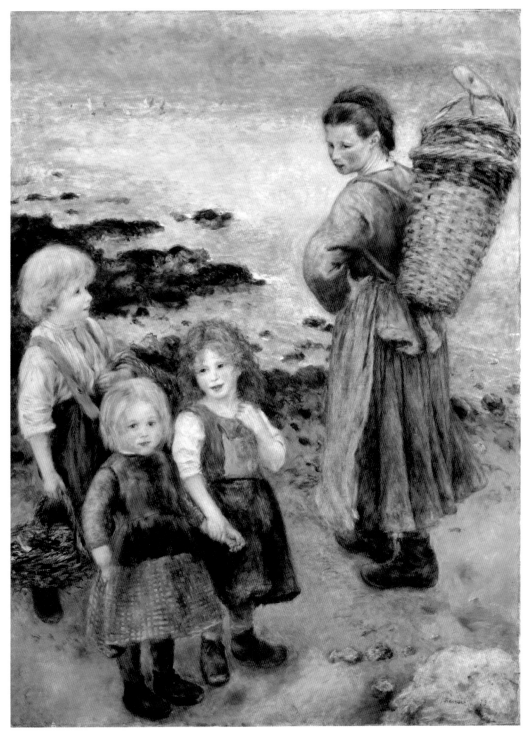

Mussel Fishers at Berneval, 1879
Oil on canvas, 176.2 x 130.2 cm (69¼ x 51¼ in)
• The Barnes Foundation, Philadelphia

The naturalness of this scene of a peasant woman and her children is rendered slightly surreal by the prismatic blend of colours of the vaguely defined shore and the exotic array of blues, indigos and violets of the sea and the sky.

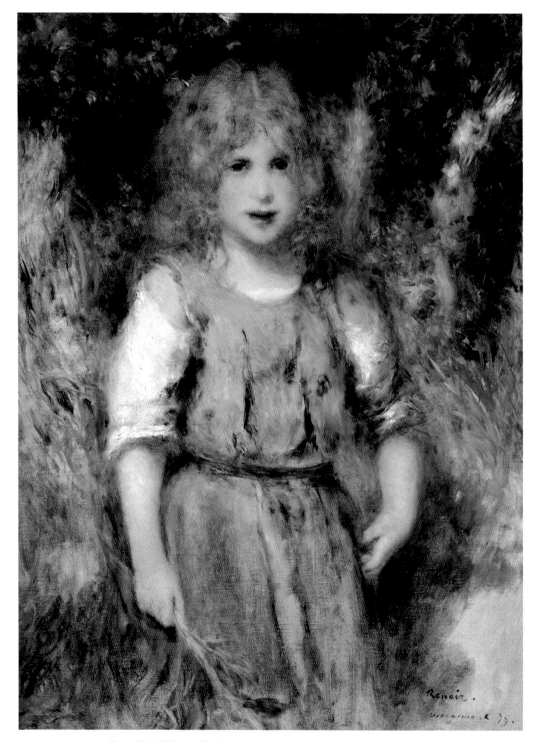

Gypsy Girl, 1879
Oil on canvas, 73 x 54 cm (28³/₄ x 21¹/₄ in)
• Private Collection

The free, apparently impermanent life of the child in this dreamlike picture is conveyed to us in the hypnotic merging of figure and background, as if the girl has just emerged from it and might yet prove to be a mirage.

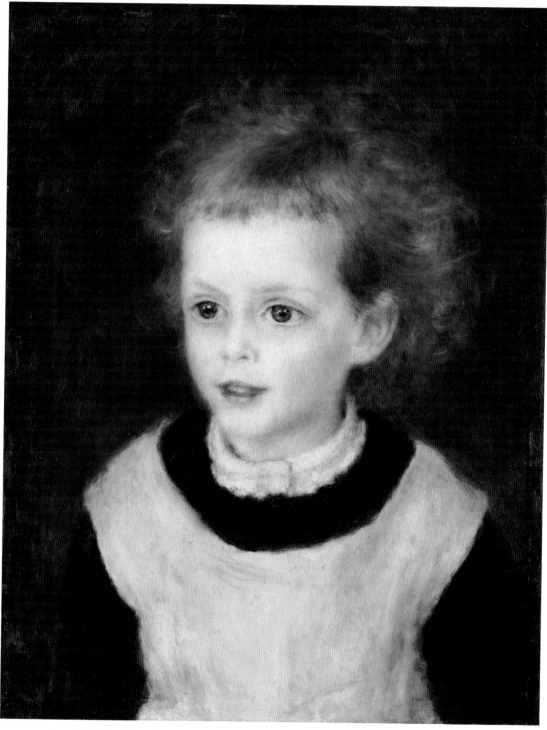

Marguerite-Thérèse Bérard, 1879
Oil on canvas, 41 x 32.4 cm (16 x 12³/₄ in)
• Metropolitan Museum of Art, New York

The wide-eyed innocence of the little daughter of Renoir's patron and friend, the financier and diplomat Paul Bérard, is almost alarming in its frank depiction of what seems to be a rather sickly little girl.

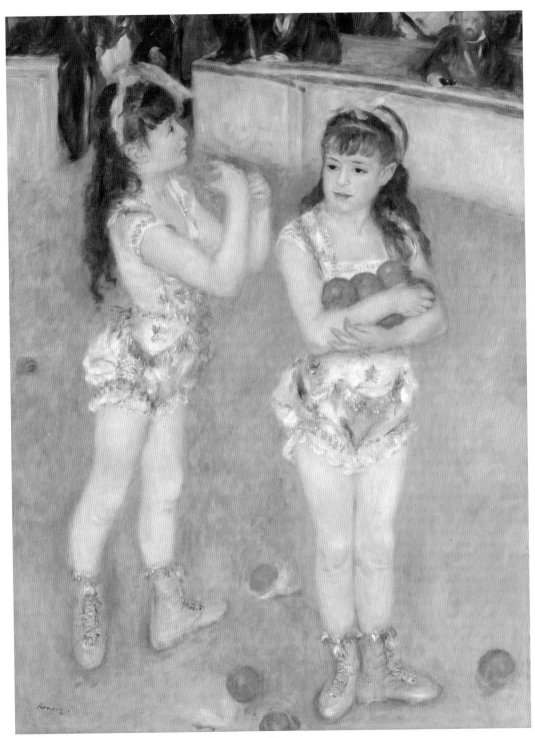

Acrobats at the Cirque Fernando, 1879
Oil on canvas, 131.5 x 99.5 cm (51³/₄ x 39¹/₄ in)
• The Art Institute of Chicago, Chicago

These two sisters were members of the Cirque Fernando resident at Montmartre from 1875. The girl on the right is holding oranges wrapped in tissue, at the time a standard form of tribute from an appreciative audience.

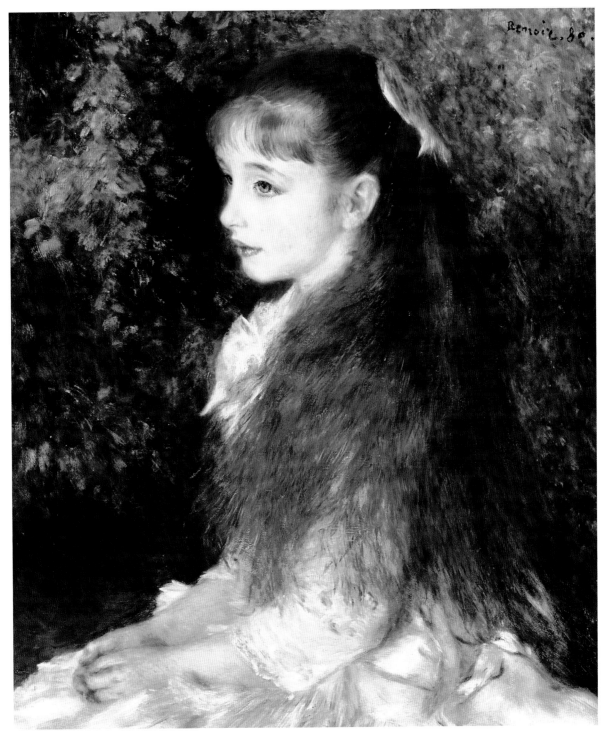

Portrait of Mademoiselle Irène Cahen d'Anvers, 1880
Oil on canvas, 65 x 54 cm (25$\frac{1}{2}$ x 21$\frac{1}{4}$ in)
• E.G. Bührle Collection, Zurich

A rare portrait of a child in almost full profile lends the sitter a slightly melancholy elegance.
Irène Cahen d'Anvers (1872–1963) was the daughter of a wealthy Jewish family who, as an
old lady, narrowly escaped being sent to Auschwitz.

A Restless Decade

In the early 1880s, the comfortable income Renoir earned from portraits enabled him to travel abroad for the first time. But these journeys and encounters provoked an uncertainty in both his methods and in what he was trying to achieve.

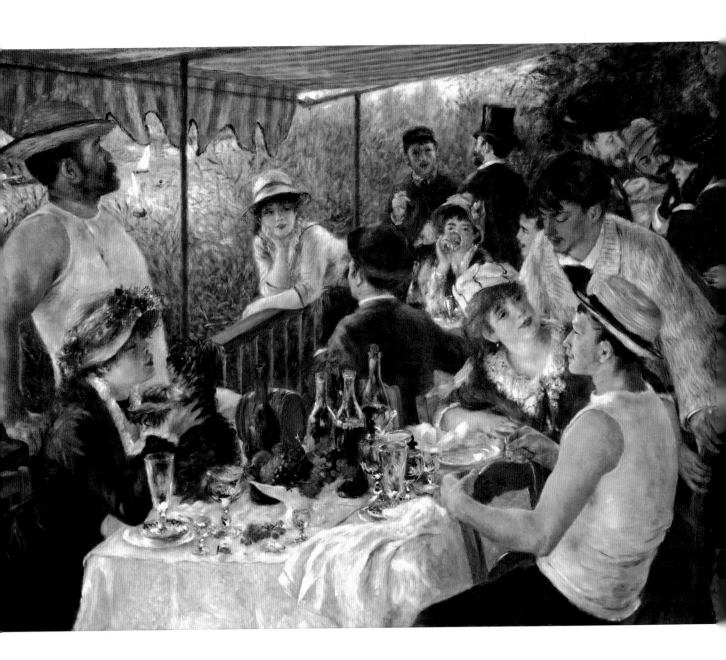

The Luncheon of the Boating Party, 1880–81
Oil on canvas, 130 x 173 cm (51¼ x 68 in)
• The Phillips Collection, Washington, DC

Above all, this icon of Impressionism is about friendship, a subject that had been under-represented in the history of art to that point. As with some of his earlier paintings, Renoir's models for this picture were his own friends.

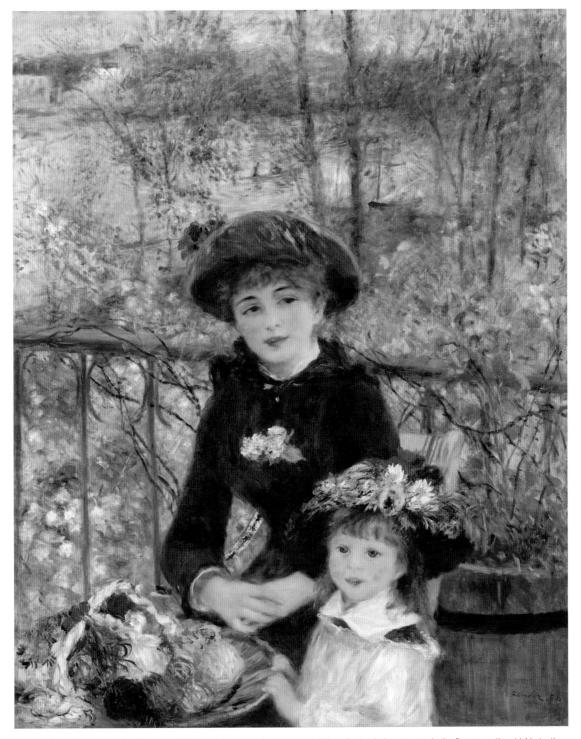

Two Sisters, or On the Terrace, 1881
Oil on canvas, 100.6 x 81 cm (39$^{1}/_{2}$ x 32 in)
• The Art Institute of Chicago, Chicago

The panoply of colours in this radiant painting, as seen in the flowers on the girls' hats, the balls of wool and the abundance of the foliage that seems to envelop them, lends the two sitters a timeless significance.

Pink and Blue, or The Cahen d'Anvers Girls, 1881
Oil on canvas, 119 x 74 cm (46³/₄ x 29¹/₄ in)
• Museu de Arte, São Paulo

The elaborate style of the dresses of these two little girls, together with their rather formal expressions, might suggest the paintings of the Infanta Margarita Teresa by Diego Velázquez, were the girls not in fact holding hands.

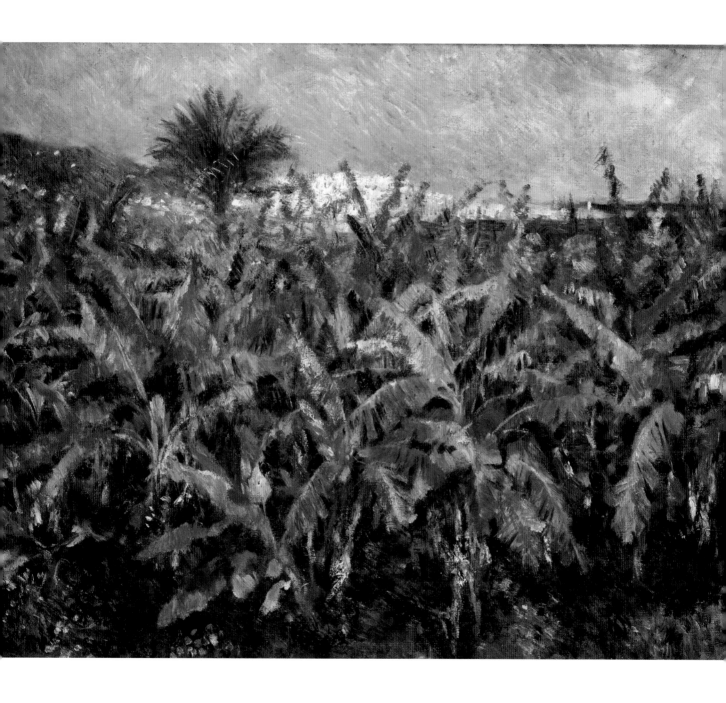

Banana Plantation, 1881
Oil on canvas, 51 x 63 cm (20 x 24³/₄ in)
• Musée d'Orsay, Paris

Renoir tackles this very different kind of landscape as if he had been painting it his whole life. The yellows and greens and browns of the waving crowd of fronds create a fascinating visual pattern.

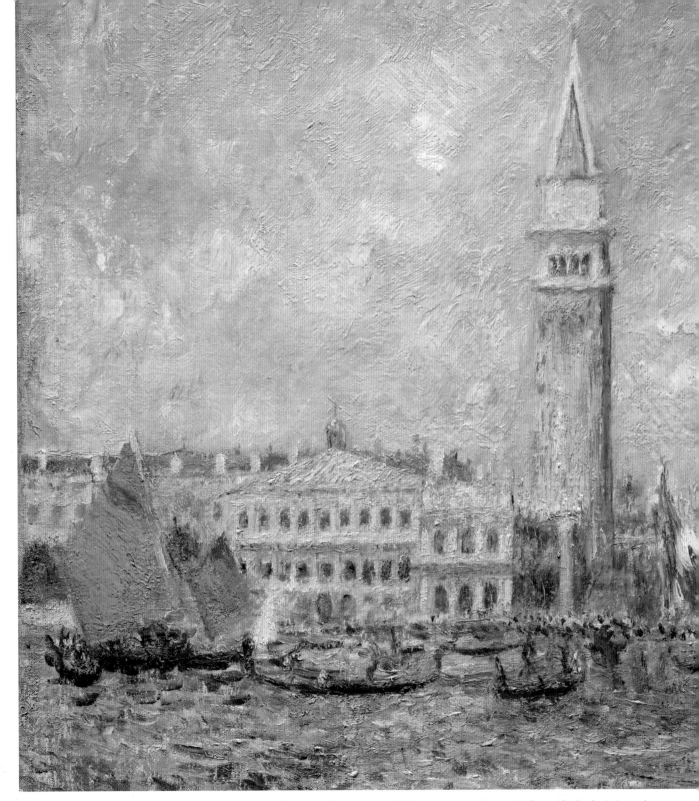

Venice, The Doge's Palace, 1881
Oil on canvas, 21.4 x 25.7 cm (8¹/₂ x 10 in)
• The Clark Art Institute, Williamstown

Another world-famous view, which Renoir rendered with a straightforward fidelity. Again, he made use of the water to distribute coloured reflections so as to soften the prominent blues of sky and lagoon.

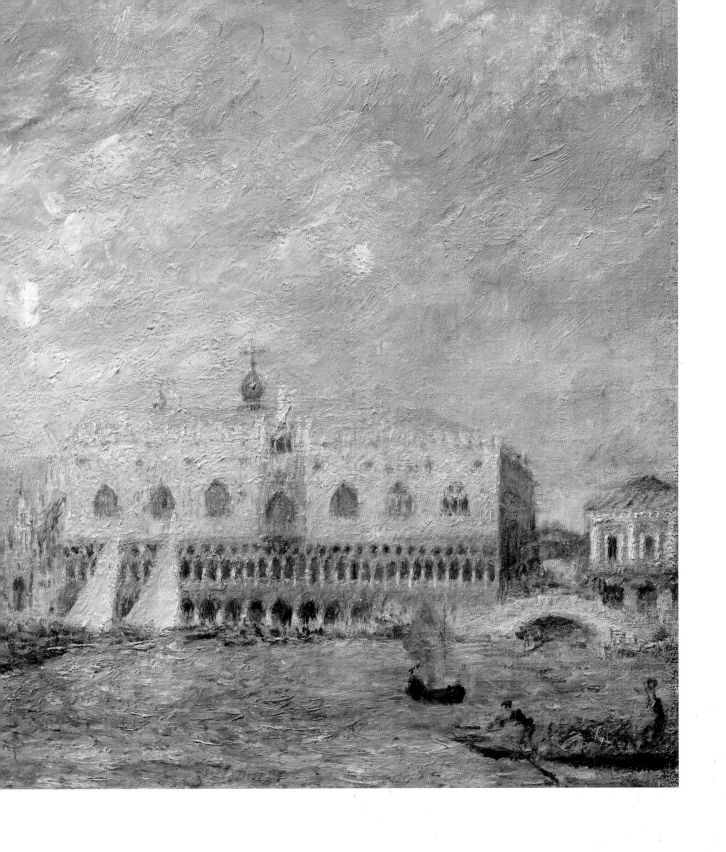

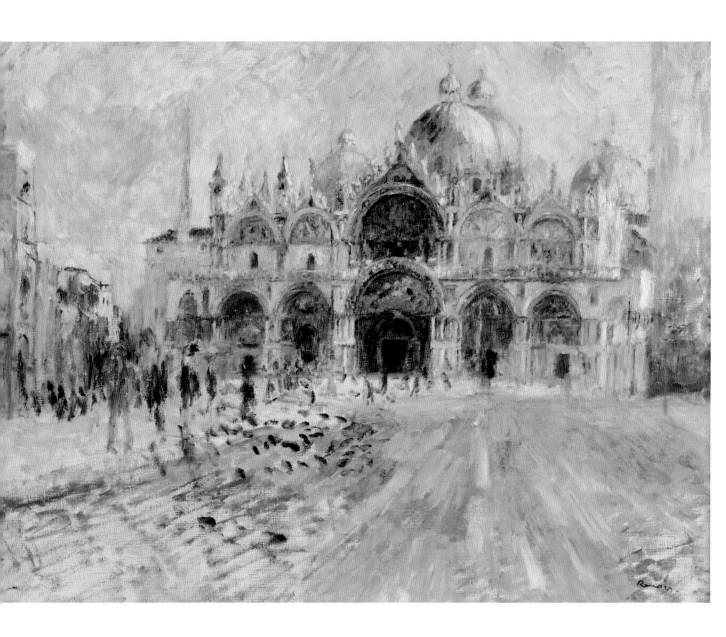

The Piazza San Marco, 1881
Oil on canvas, 89.5 x 104.4 cm (35$\frac{1}{4}$ x 41 in)
• Minneapolis Institute of Arts, Minneapolis

An apparently unfinished image, this depiction of St Mark's in Venice, and the people milling around in the square in front of it, stands out among Renoir's images of the city for the almost Expressionist energy with which the foreground marks propel us towards the famous cathedral.

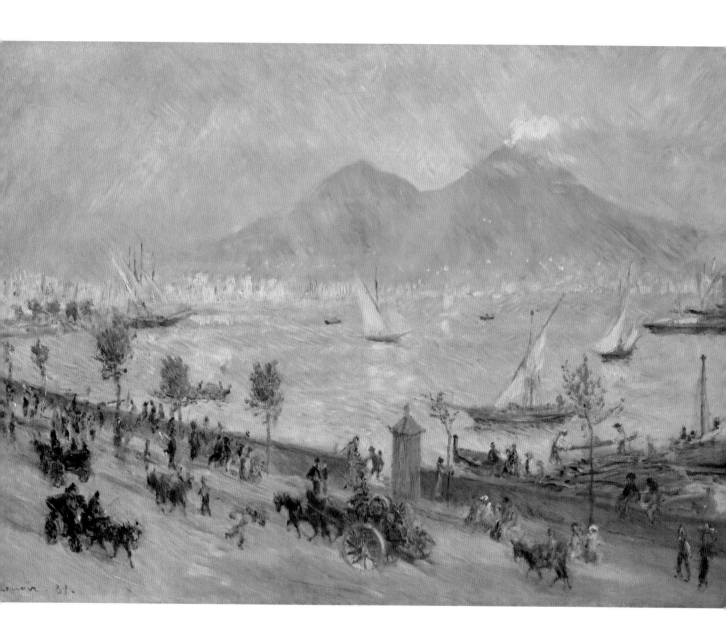

The Bay of Naples with Vesuvius in the Background, 1881
Oil on canvas, 57.9 x 80.8 cm (22³/₄ x 31³/₄ in)
• The Clark Art Institute, Williamstown

Renoir's trip to Italy in early 1881 was life-changing. Feeling that Impressionism was a dead end, he was overwhelmed by the Pompeian frescoes in Naples. From now on, he looked to the past to plot a course to the future.

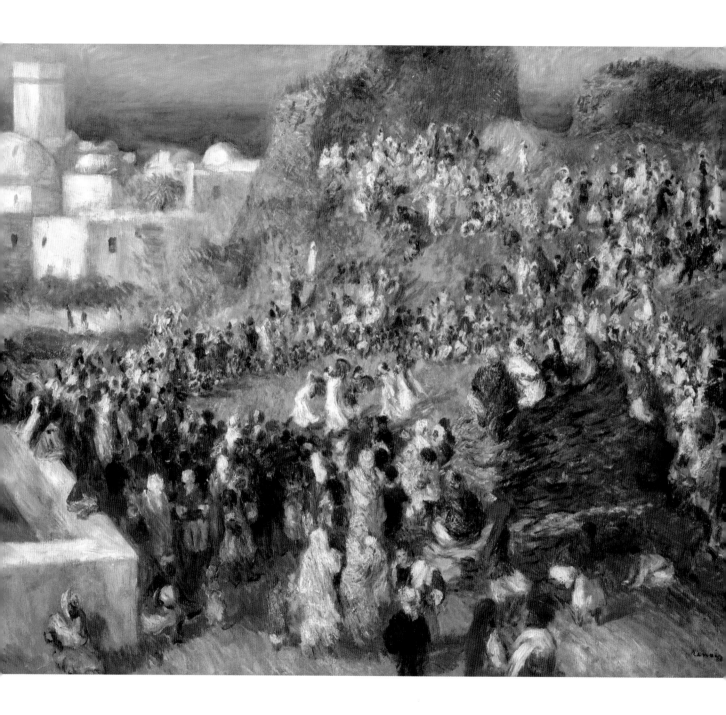

The Mosque, or Arab Festival, 1881
Oil on canvas, 49 x 67 cm (19¼ x 26½ in)
• Private Collection

The Algerian subject matter, the flash of red fezzes, the whirling social *mêlée* of which the painter understands little, all add up to the kind of exotic scene that Eugène Delacroix might have painted some 50 years earlier.

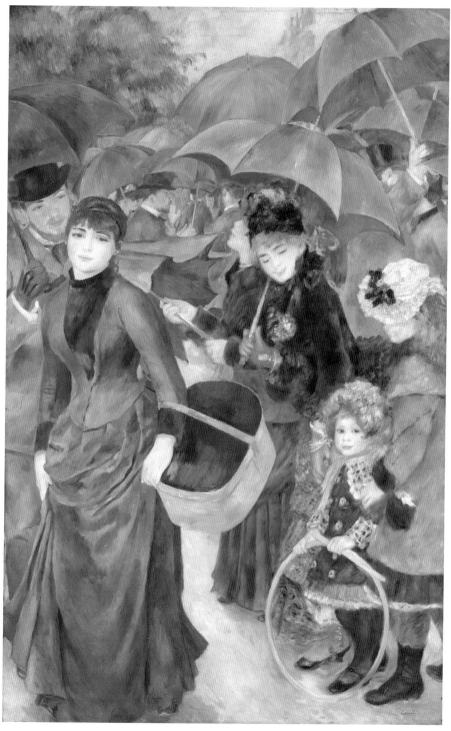

The Umbrellas, *c.* **1881–86**
Oil on canvas, 180.3 x 114.9 cm (71 x 45¹/₄ in)
• National Gallery, London

In 1916, Renoir received a letter from 100 British artists and collectors congratulating him that, as the result of a bequest, *The Umbrellas* had recently been hung in the National Gallery in London. Britain had been slow to recognize Impressionism.

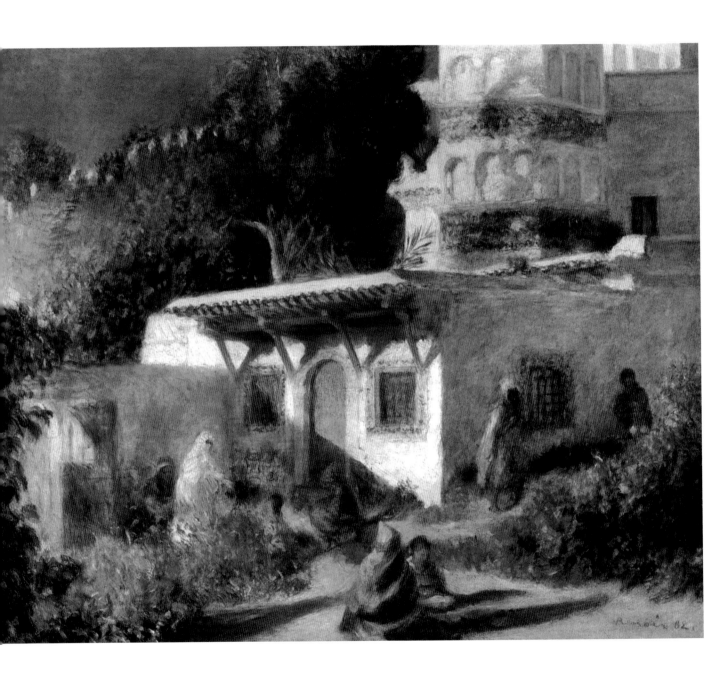

Mosque at Algiers, 1882
Oil on canvas, 49 x 59 cm (19¼ x 23¼ in)
• Private Collection

Renoir, in fact, did little painting on his first trip to Algeria, but found himself dazzled by the omnipresence of white in buildings, in roads and in clothing, realizing its value as a colour for perhaps the first time.

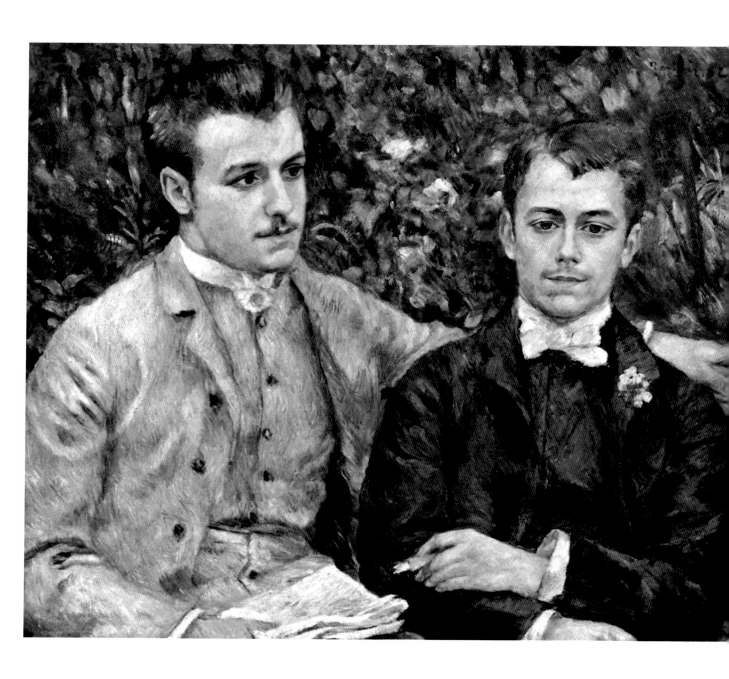

Portrait of Charles and Georges Durand-Ruel, 1882
Oil on canvas, 65 x 81 cm (25½ x 31 in)
• Durand-Ruel Collection, Paris

These two sons of Renoir's dealer, Paul Durand-Ruel, are portrayed with great sensitivity, their mutual affection conveyed in the slight angle at which Charles is turned towards his brother, as if poised to offer some word of fraternal reassurance.

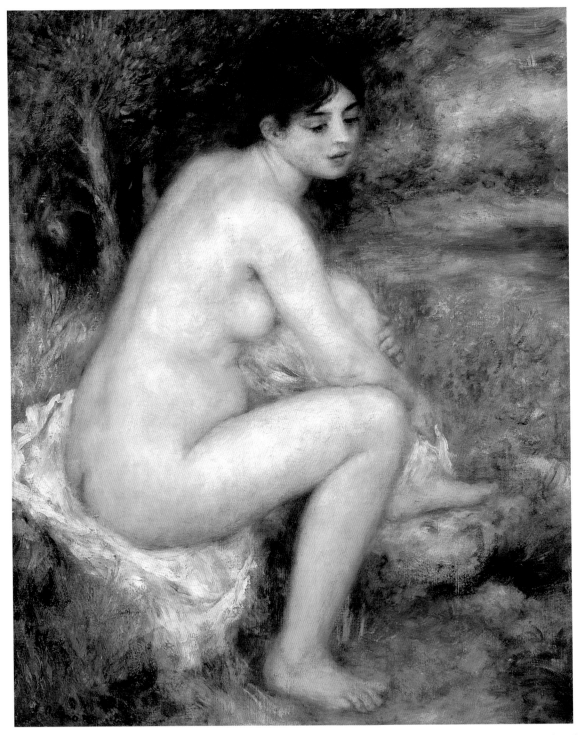

Nude in a Landscape, 1883
Oil on canvas, 65 x 52 cm (25$\frac{1}{2}$ x 20$\frac{1}{2}$ in)
• Musée de l'Orangerie, Paris

In this painting, Renoir returns to the outdoor nude, a subject that had interested him since the 1860s. Here the figure is realized with greater clarity of line than anything he had painted since then, though the landscape setting remains Impressionist.

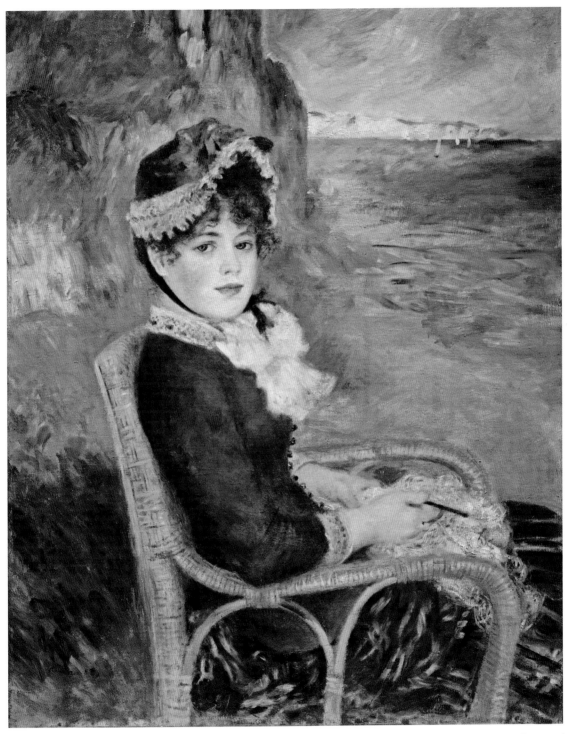

By the Seashore, 1883
Oil on canvas, 92.1 x 72.4 cm (36¼ x 28½ in)
• Metropolitan Museum of Art, New York

This portrait of Renoir's lover and eventual wife, Aline Charigot, is rendered with the same clarity of line he observed in Jean-Auguste-Dominique Ingres, although the setting is a frenzy of blurred landscape features from which the figure seems wholly separate.

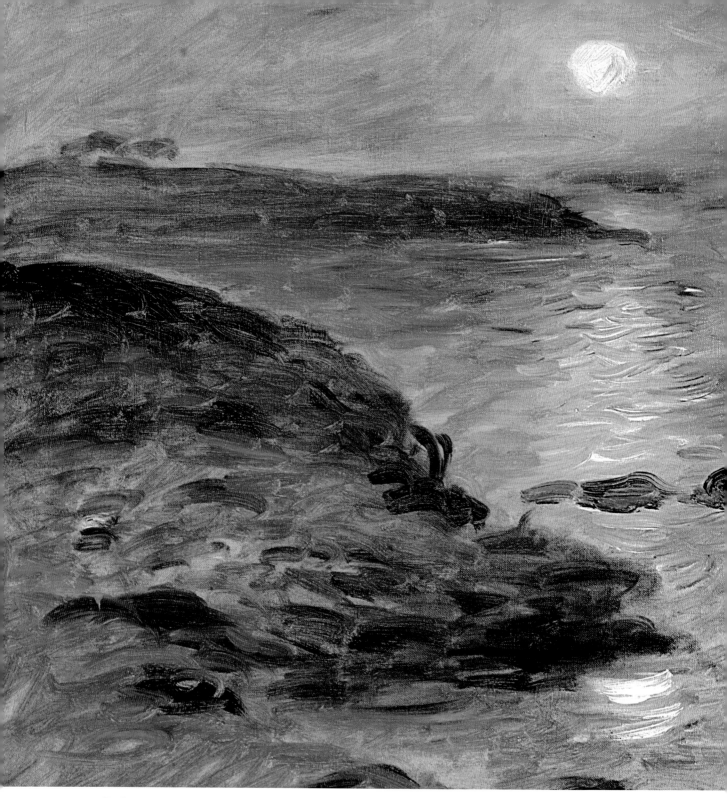

The Setting of the Sun at Douarnenez, 1883
Oil on canvas, 53.7 x 64.4 cm (21¼ x 25¼ in) • Private Collection

In this landscape, the golden brown of the earth, the pink and gold of the sky surrounding the sun and the white gold of the sun itself, all seem like different intensities of the same illumination.

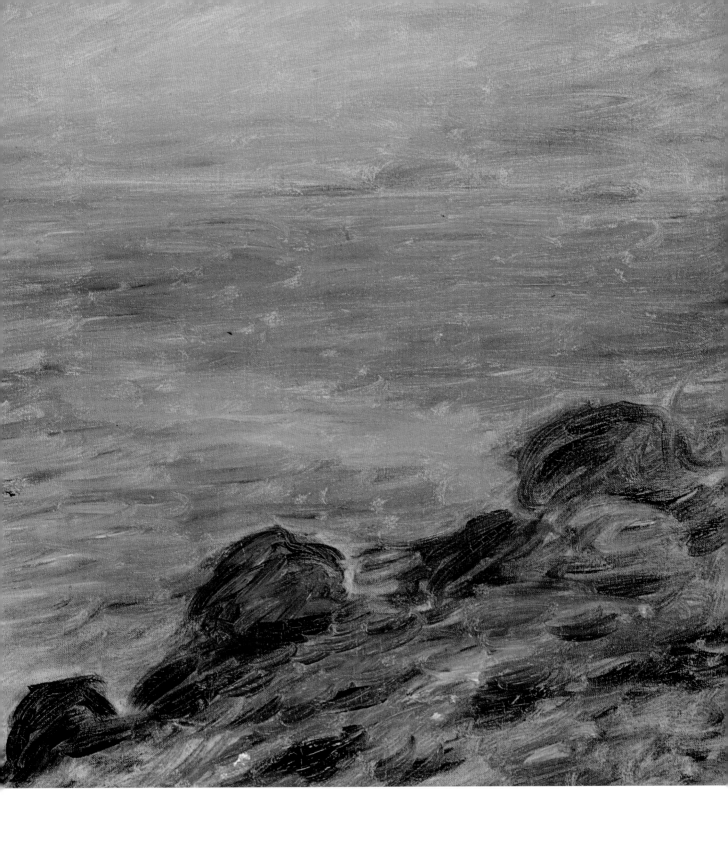

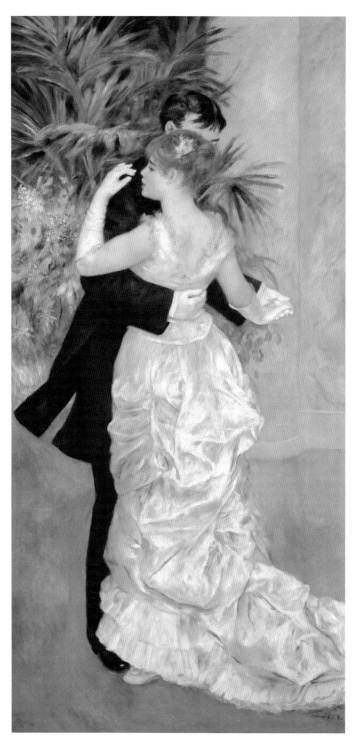

Dance in the City, 1883
Oil on canvas, 180 x 90 cm (70³/₄ x 35¹/₂ in)
• Musée d'Orsay, Paris

The face of the male dancer is obscured in this picture of a couple dancing, but the slightly open lips of the woman's face in profile and the eloquence of a gloved hand resting lightly on his shoulder speak of the intimacy that exists between them.

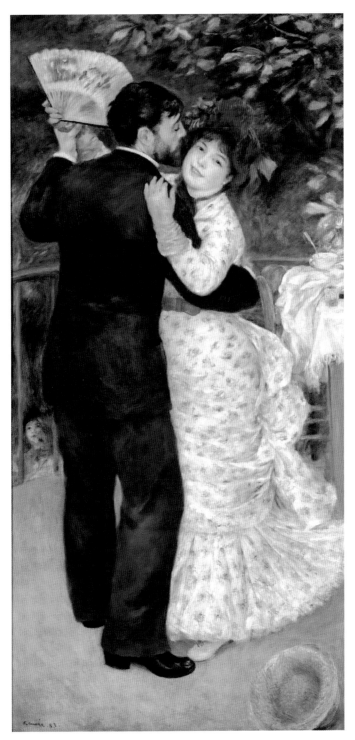

Dance in the Country, 1883
Oil on canvas 180 x 90 cm (70³/₄ x 35¹/₂ in)
• Musée d'Orsay, Paris

Who better than Renoir's lover, Aline Charigot, a country girl from Burgundy, to play the role of the carefree dancer in this rural shindig? Renoir admitted she danced beautifully, and here the painter has conveyed wonderfully her unselfconscious pleasure.

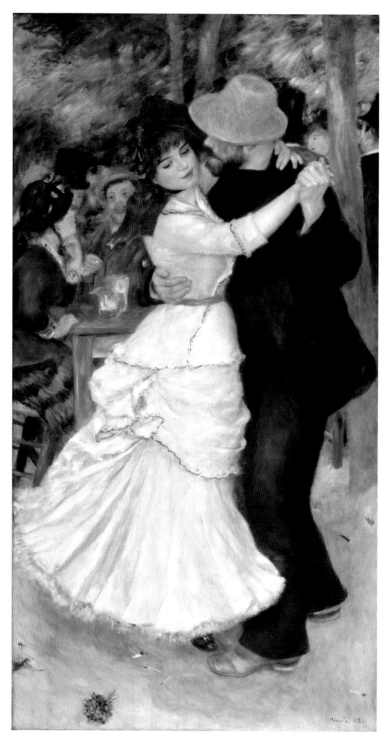

Dance at Bougival, 1883
Oil on canvas, 181.9 x 98.1 cm (71$\frac{1}{2}$ x 38$\frac{1}{2}$ in)
• Museum of Fine Arts, Boston

As with *Dance in the City*, the model for this image was Suzanne Valadon, later to become a fine painter herself. In this picture, she seems quietly enraptured by the intense interest of her dancing partner.

In the Luxembourg Gardens, 1883
Oil on canvas, 64 x 53 cm (25¼ x 21 in)
• Private Collection

This strange composition seems almost to anticipate surrealism, given the disconnection of the various figures and the vague twilight world they appear to inhabit. Are we really in the Luxembourg Gardens?

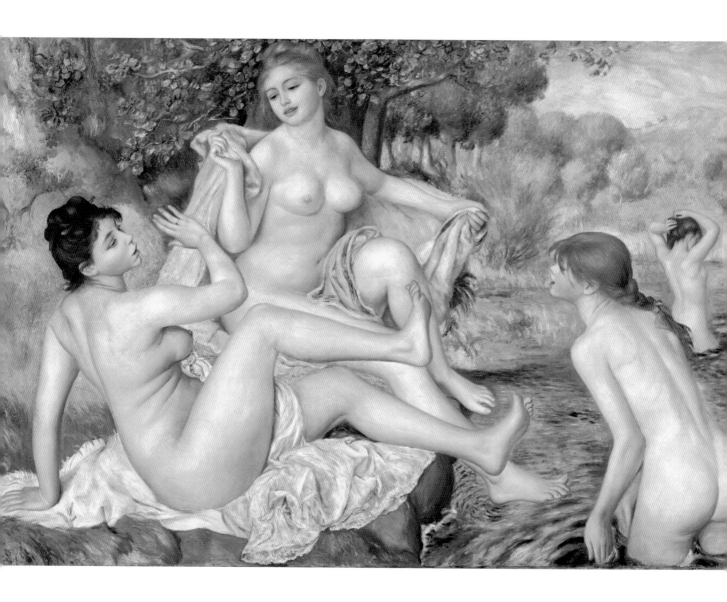

The Large Bathers, 1884–87
Oil on canvas, 117.9 x 170.9 cm (46^1/$_2$ x 67^1/$_4$ in)
• Philadelphia Museum of Art, Philadelphia

Renoir laboured over this monumental canvas for three years, but the lukewarm critical reaction to the work, a poor sale price and his own misgivings about what he had achieved brought an end to his experiments with the Neoclassical style.

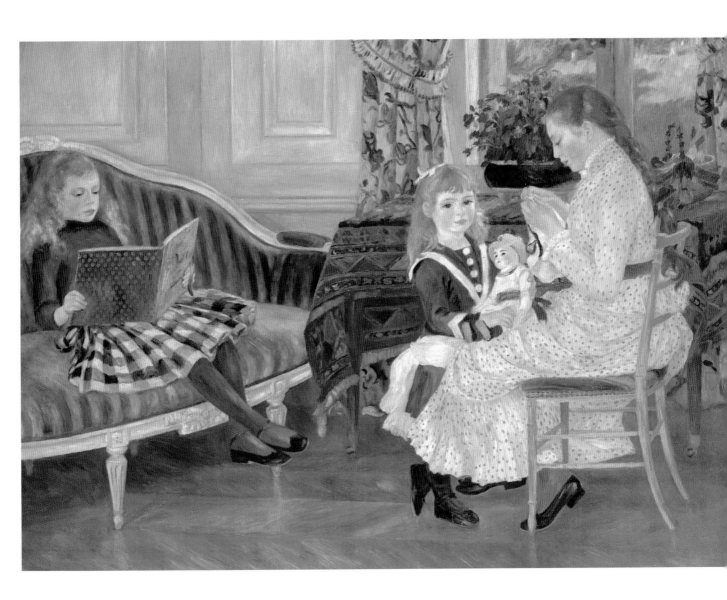

Children's Afternoon at Wargemont, 1884
Oil on canvas, 127 x 173 cm (50 x 68 in)
• Alte Nationalgalerie, Berlin

The three girls in this painting are the daughters of the financier Paul Bérard, painted at his château of Wargemont near Dieppe, where in the early 1880s Renoir often stayed.

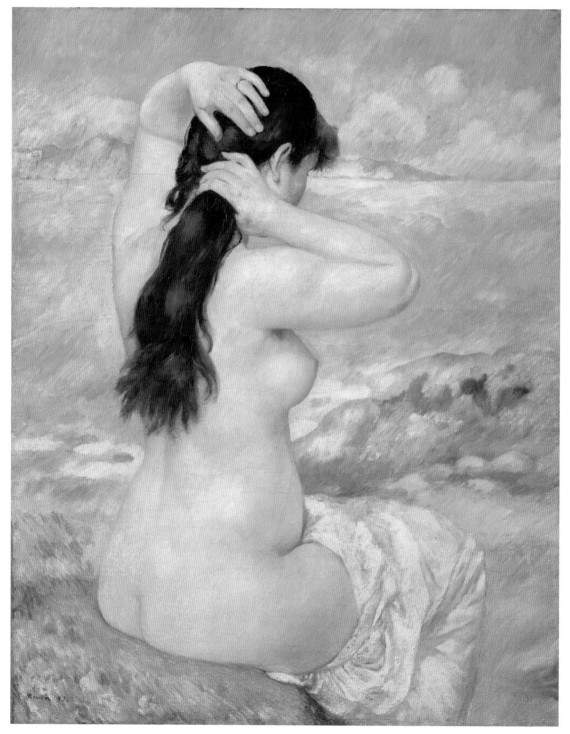

Bather Arranging Her Hair, 1885
Oil on canvas, 91.9 x 73 cm (36¼ x 28¾ in)
• The Clark Art Institute, Williamstown

Another painting from Renoir's so-called 'Ingres Period', when he struggled to reconcile Impressionism with the tradition of painting he loved. Here the coolly Classical nude may in fact be wondering what she is doing in this sketchy Impressionist landscape.

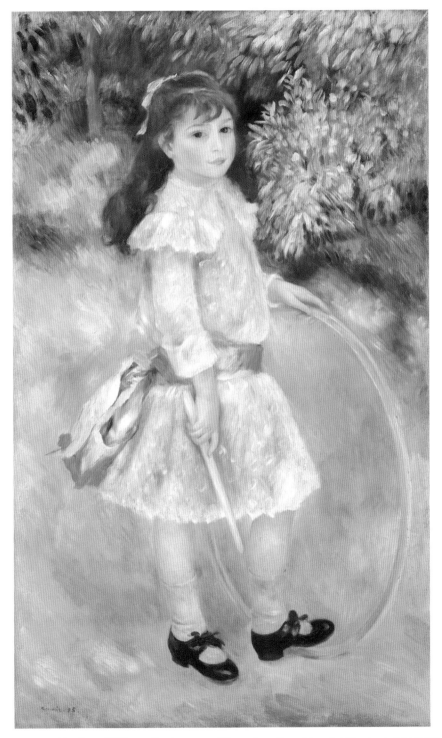

Girl with a Hoop, 1885
Oil on canvas, 125.7 x 76.6 cm (49½ x 30¼ in)
• National Gallery of Art, Washington, DC

Renoir was one of the most sensitive painters of children because he seems to have understood them so well. The child's left foot cocked impatiently on the hoop, as well as a vaguely peevish expression, suggests she would rather be playing.

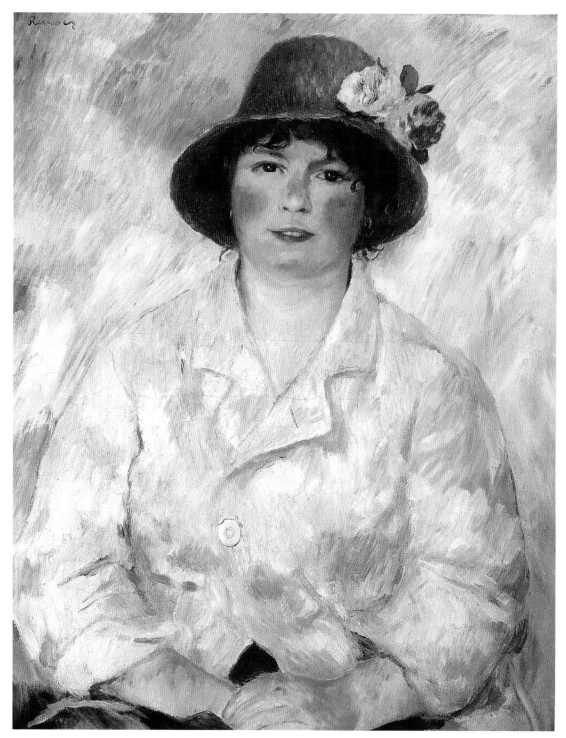

Portrait of Madame Renoir (Aline Charigot), 1885
Oil on canvas, 65.4 x 54 cm (25³/₄ x 21¹/₄ in)
• Philadelphia Museum of Art, Philadelphia

Renoir's loving portrait of his clearly devoted partner, Aline Charigot, conveys the simple generosity of a woman on whom he quickly came to depend. This rosy-cheeked country girl was also the physical embodiment of his feminine ideal.

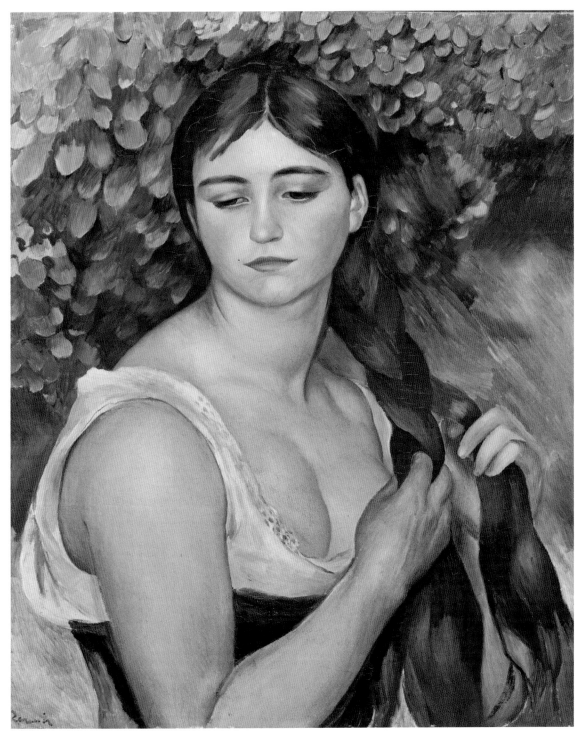

Girl Braiding Her Hair, 1885
Oil on canvas, 57 x 47 cm (22½ x 18½ in)
• Museum Langmatt, Baden

The model for this melancholy canvas was Suzanne Valadon, who had already posed for Renoir in two of the three *Dance* canvases of 1883 (*see* pages 94 and 96). She also appears as one of the bathers in *The Large Bathers* (*see* page 98).

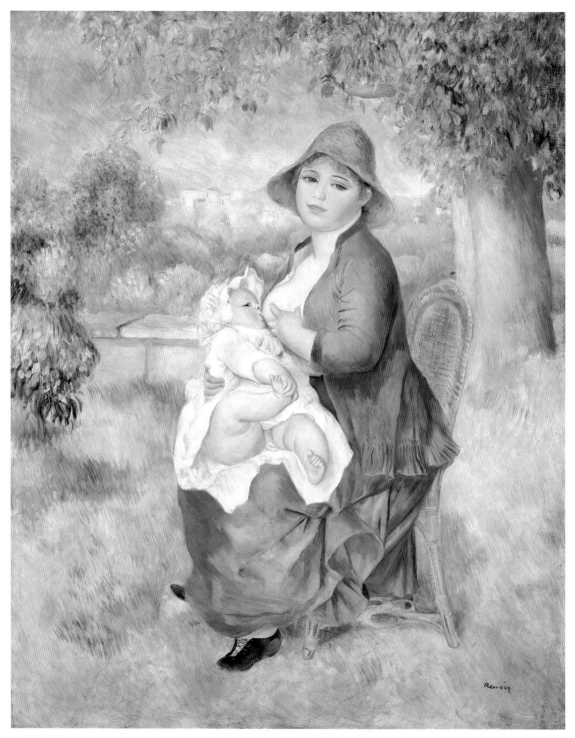

Mother and Child, Maternity, 1886
Oil on canvas, 81 x 65 cm (35³/₄ x 28¹/₄ in)
• Private Collection

This is one of many very similar images Renoir made in the year after the birth of his eldest son Pierre, of the baby feeding at the breast of his mother, Renoir's lover Aline Charigot.

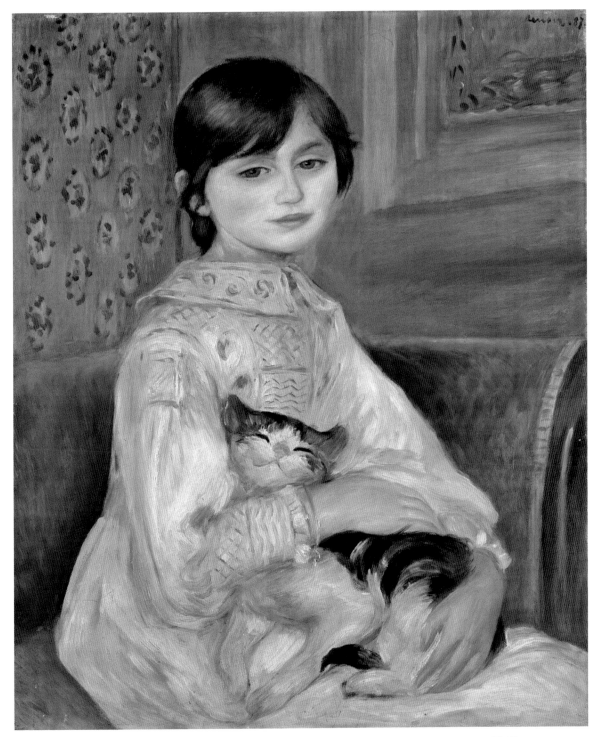

Julie Manet with Cat, 1887
Oil on canvas, 65 x 54 cm (25½ x 21¼ in)
• Musée d'Orsay, Paris

Julie Manet (1878–1966) was the daughter of Eugène Manet (1833–92;
Édouard's brother), and Renoir's friend, Berthe Morisot. When Morisot died,
Renoir was appointed Julie's guardian.

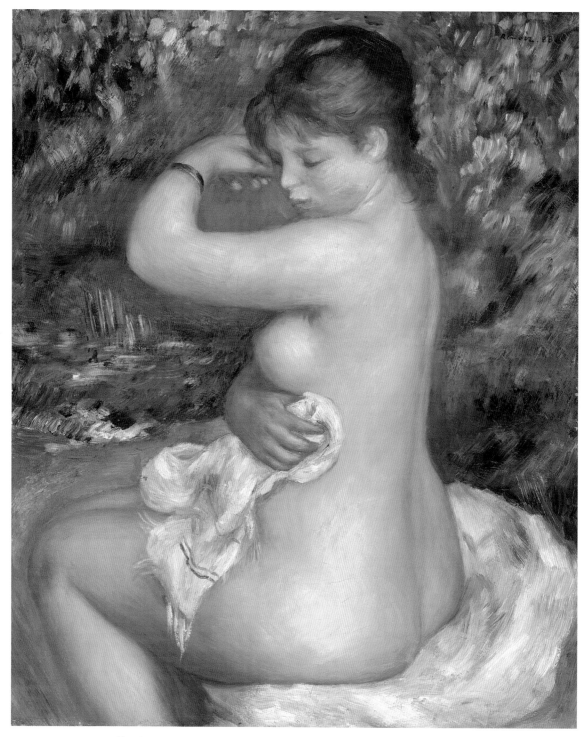

After the Bath, 1888
Oil on canvas, 66 x 54.6 cm (26 x 21¹/₂ in)
• Private Collection

Following the disappointment of *The Large Bathers*, Renoir did not abandon the nude; but the sudden change in style and mood, from the precisely depicted frivolity of that work to the soft brushwork and intimacy of this one, is remarkable.

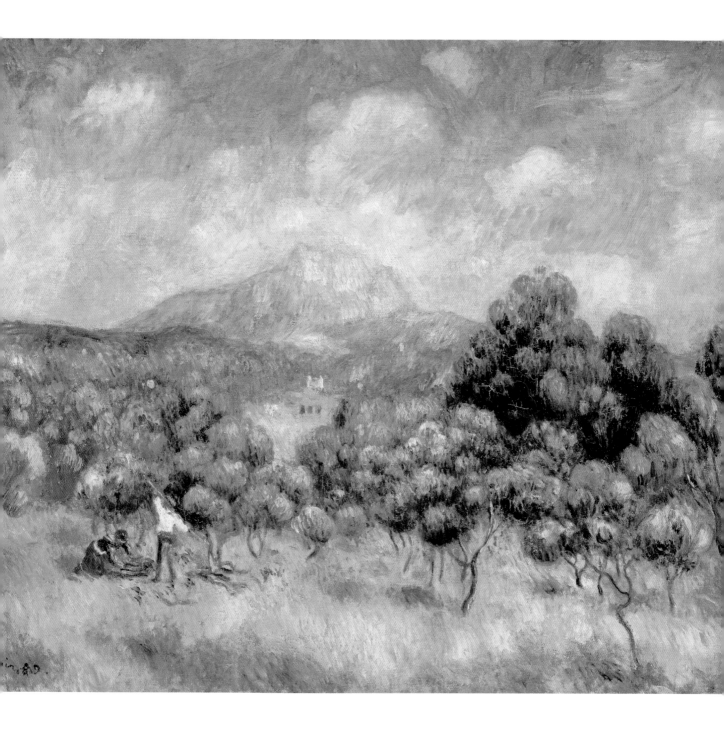

Mont Saint-Victoire, 1889
Oil on canvas, 54.3 x 66 cm (21¼ x 26 in)
• The Barnes Foundation, Philadelphia

Renoir painted this image while staying with Paul Cézanne. The pair apparently worked side by side on this most famous of all Cézanne's motifs. But Renoir's feathery brushwork conveys details that were of little interest to Cézanne.

A Living Dream

Commercial success, marriage to his long-term partner and the births of his children brought Renoir a settled contentment that seemed hardly impaired by the debilitating illness of his last decades. His late paintings share a willed, dreamlike vision of earthly bliss.

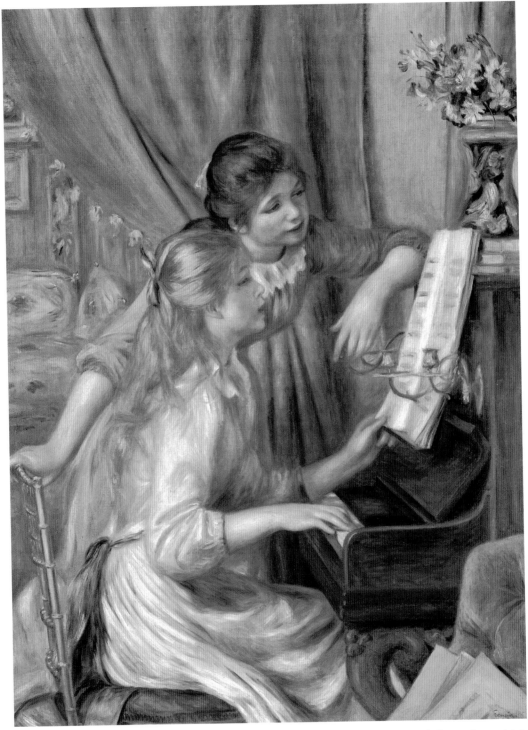

Young Girls at the Piano, 1892
Oil on canvas, 116 x 90 cm (45³/₄ x 35¹/₂ in)
• Musée d'Orsay, Paris

The purchase of this picture by the Musée du Luxembourg in the year it was painted set the official imprimatur on what was already a growing public acceptance of the Impressionist style.

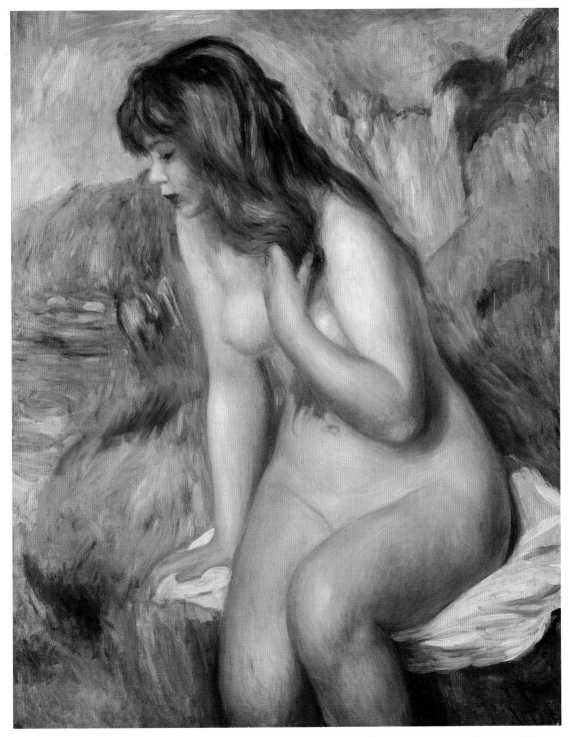

Bather Seated on a Rock, 1892
Oil on canvas, 80 x 64 cm (31$\frac{1}{2}$ x 25$\frac{1}{4}$ in)
• Private Collection

The girl stares into the water unaware of being observed, her thoughts lost in the flickering reflections. Very few painters have captured innocent rapture in a female nude with such unselfconscious tenderness.

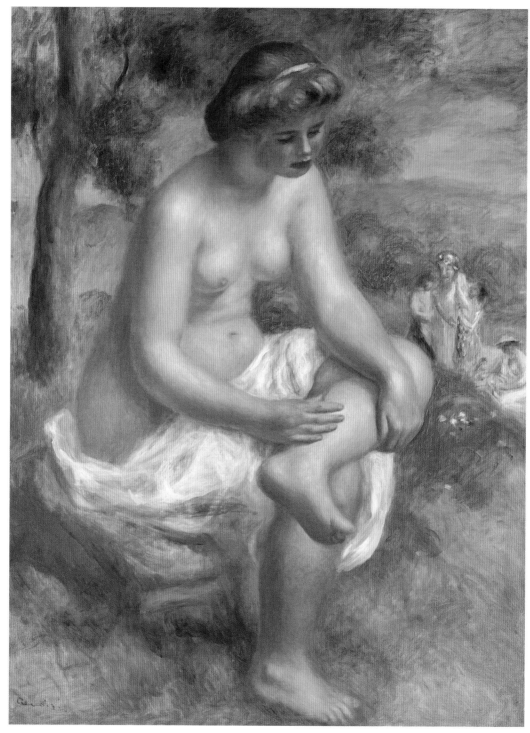

Seated Bather in a Landscape, or Eurydice, 1895–1900
Oil on canvas, 116 x 89 cm (45³/4 x 35 in)
• Musée Picasso, Paris

This canvas once belonged to Pablo Picasso, one of several Renoirs in the collection of the Andalusian genius. Renoir's late nudes are thought to have had an influence on Picasso's 'Neoclassical' paintings of the early 1920s.

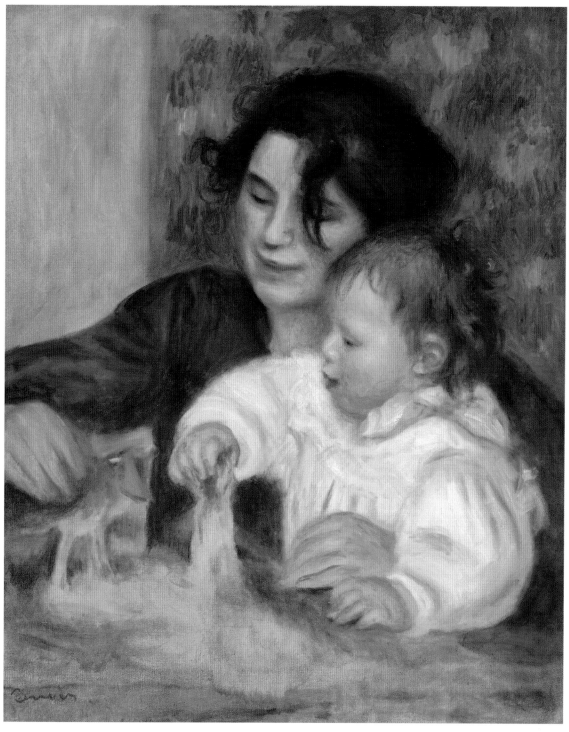

Gabrielle and Jean, 1895–96
Oil on canvas, 65 x 54 cm (25$\frac{1}{2}$ x 21$\frac{1}{4}$ in)
• Musée de l'Orangerie, Paris

Gabrielle Renard was just 15 years old when she came to look after the second child of her cousin, Renoir's wife Aline. It is clear from this scene how much she enjoyed the work.

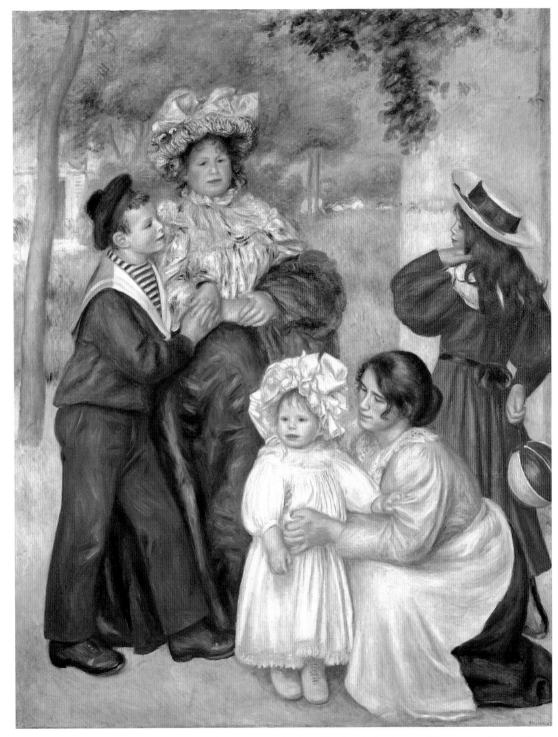

The Artist's Family, 1896
Oil on canvas, 173 x 140 cm (68 x 55 in)
• The Barnes Foundation, Philadelphia

This large and rather formal family portrait makes something monumental out of the members of Renoir's family, a subject he had been painting in smaller groups in more intimate genre paintings for several years.

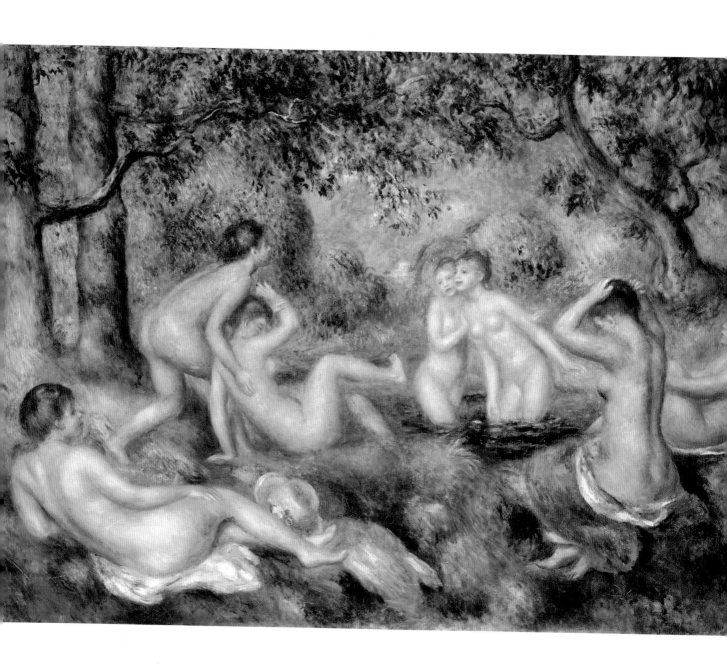

Bathers in the Forest, *c.* 1897
Oil on canvas, 73.7 x 99.7 cm (29 x 39¼ in)
• The Barnes Foundation, Philadelphia

Here Renoir returns to the subject of a group of bathers. Now financially secure and domestically content, he had settled into a comfortable late style combining soft, fluid forms with, at times – as in this work – prismatic Impressionist colour.

Bather and Maid, c. 1900

Oil on canvas, 145.1 x 94.9 cm (57¼ x 37¼ in)
• The Barnes Foundation, Philadelphia

If Édouard Manet had painted this subject, the gaze of the nude would have challenged our voyeurism. Renoir's model seems almost to enjoy our attention, an attitude that does not sit comfortably with modern mores.

The Road to Essoyes, 1901
Oil on canvas, 46.2 x 55.2 cm (18¼ x 21¾ in)
• Private Collection

Essoyes was the village in Burgundy from which Aline hailed, and to which Renoir and his wife made regular visits, eventually buying a house there in 1898. It is also where in 1919 he was buried very close to Aline.

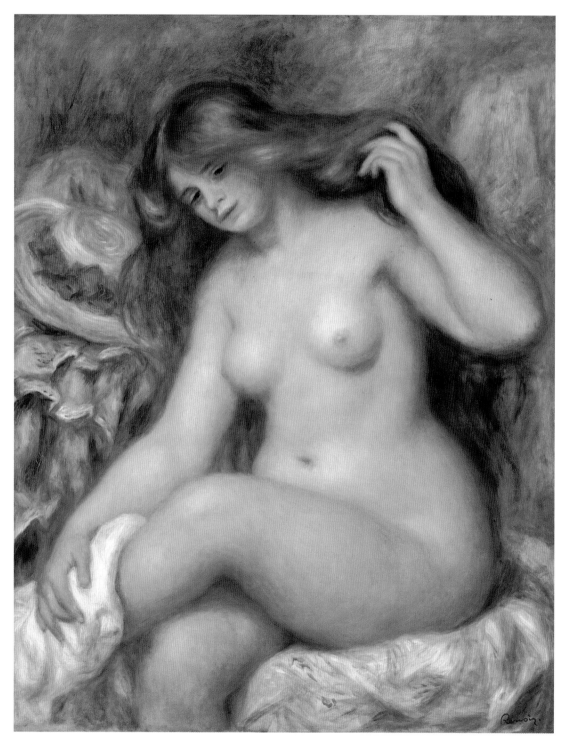

Bather, c. 1903
Oil on canvas, 92 x 73 cm (36¹/₄ x 28³/₄ in)
• Kunsthistorisches Museum, Vienna

This image, one he made several versions of in the early 1900s, is the archetypal Renoir nude: the rosy cheeks, the pouting red lips, the Rapunzel-length hair. A dream woman, and for Renoir, the epitome of the feminine principle.

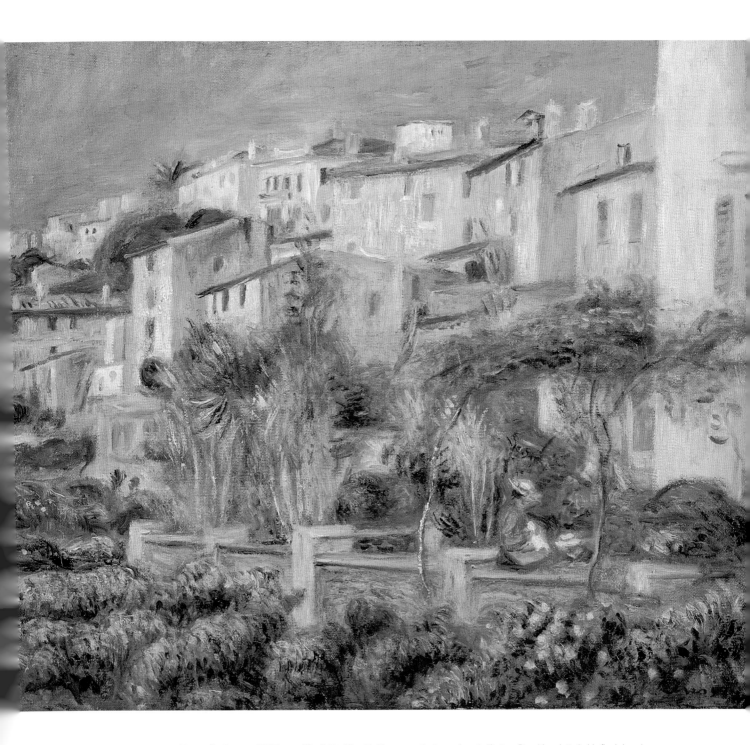

Terrace in Cagnes, 1905
Oil on canvas, 45.3 x 54.3 cm (17³/₄ x 21¹/₂ in)
• Bridgestone Museum of Art, Tokyo

The light of the Mediterranean had a profound effect on Renoir's palette in his final decades, with pinks and reds and yellows becoming dominant colours, affecting not just landscapes but everything he painted.

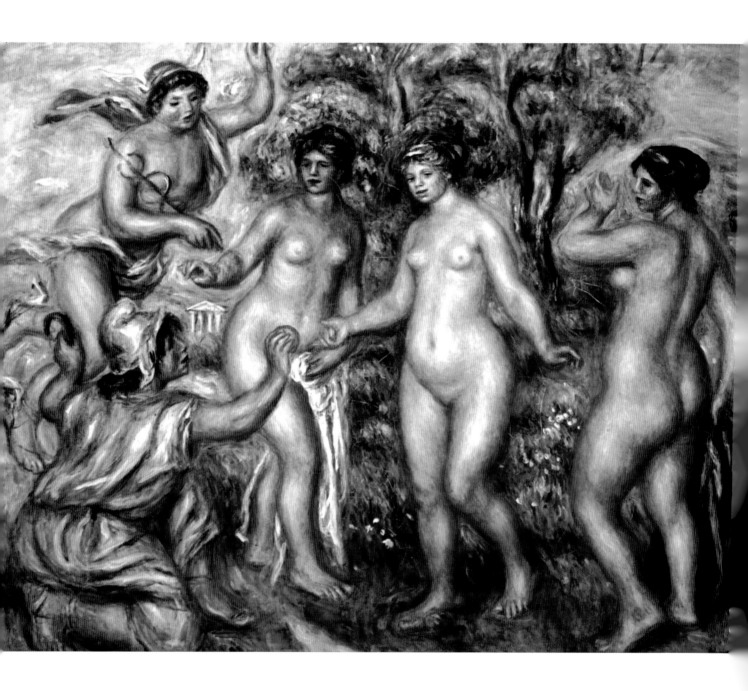

The Judgement of Paris, *c.* 1908–10
Oil on canvas, 73 x 92.5 cm (28³/₄ x 36¹/₂ in)
• Hiroshima Museum of Art, Hiroshima

This is the first version of a canvas after Peter Paul Rubens that Renoir repeated in 1913. With the help of an assistant, Richard Guino (1890–1973), he also made several sculptures of various figures from the same tableau.

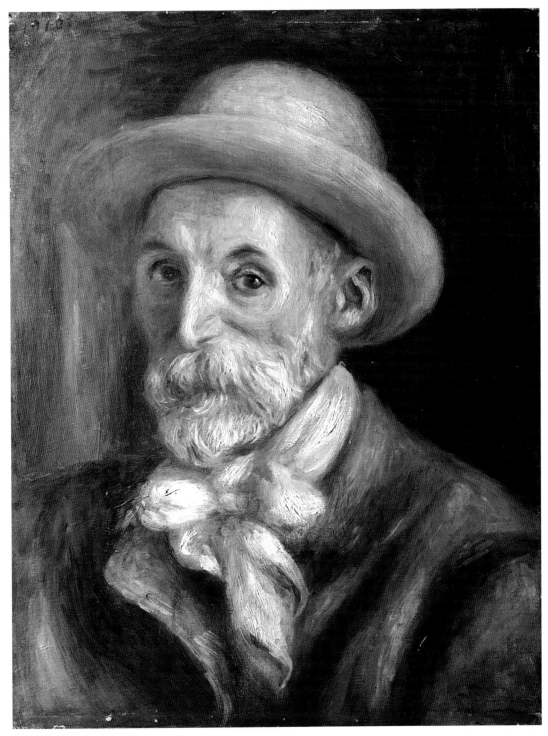

Self-Portrait, 1910
Oil on canvas, 45.7 x 38.1 cm (18 x 15 in)
• Private Collection

What a contrast to the frightened young man of the mid-1870s. In this canvas Renoir, now no longer able to walk and barely able to hold a brush in his crippled hands, looks at us with quiet, sad serenity.

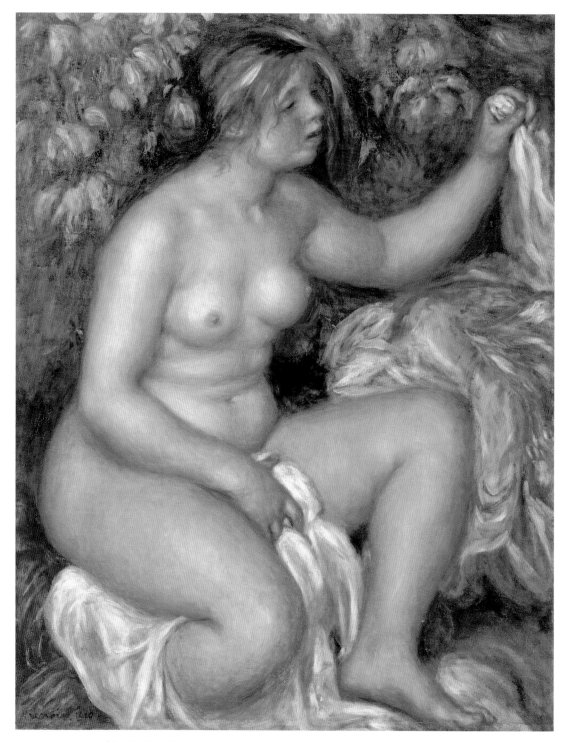

After the Bath, 1910
Oil on canvas, 95 x 76 cm (37$^{1}/_{2}$ x 30 in)
• The Barnes Foundation, Philadelphia

No matter what they may have looked like in the flesh, the older he became the more bucolic, even bovine, the nudes in Renoir's paintings seem to be, as he sought to depict what he saw as a timeless feminine essence.

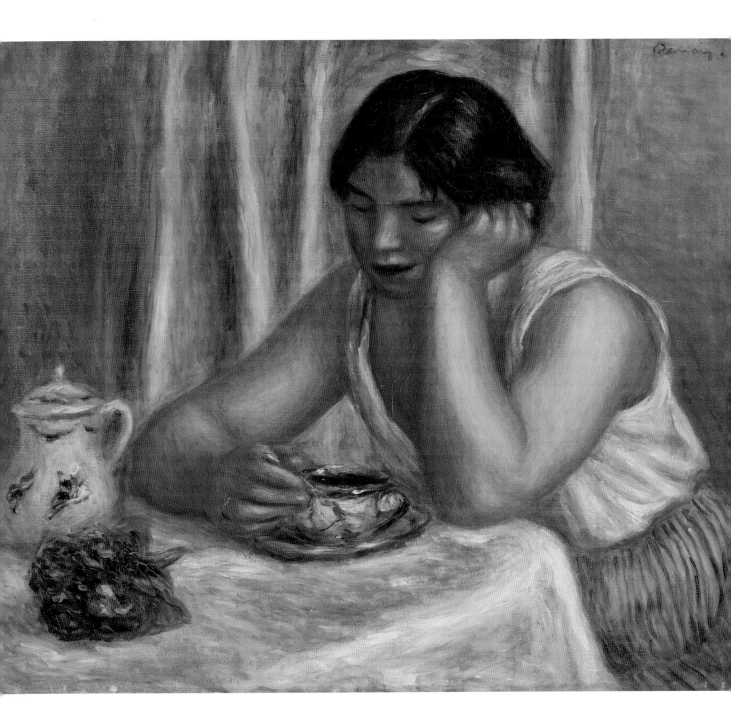

Cup of Chocolate, 1912
Oil on canvas, 54.1 x 65.1 cm (21¼ x 25½ in)
• The Barnes Foundation, Philadelphia

This picture of Gabrielle Renard is unusually contemplative for any of Renoir's paintings from the twentieth century. By the start of the First World War, Gabrielle had left the Renoir household to marry the American painter Conrad Hensler Slade (1871–1949).

Portrait of Ambroise Vollard, 1917
Oil on canvas, 102 x 83 cm (40¼ x 32¾ in)
• Nippon Television Network Corporation, Tokyo

Renoir had painted the art dealer Ambroise Vollard (1866–1939) a decade earlier, and here he is seen in the garb of a toreador, which he had recently bought in Spain. Vollard later wrote a less-than-reliable memoir of the painter.

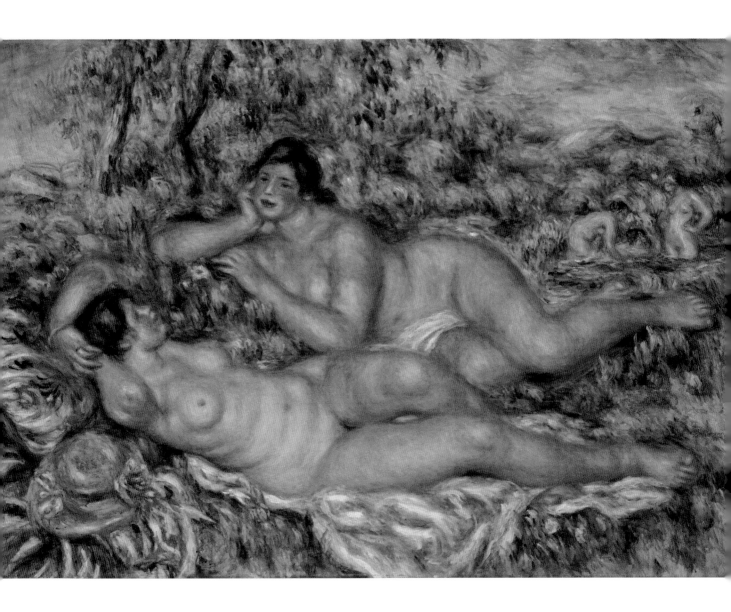

The Bathers, *c.* 1918–19
Oil on canvas, 110 x 160 cm (43¼ x 63 in)
• Musée d'Orsay, Paris

Even if Renoir had not been in such continuous pain, this large canvas would have been a considerable achievement. Sleeping little in the last years of his life, and barely able to hold a brush, his desire to paint remained undimmed.

Indexes

Index of Works

Page numbers in *italics* refer to illustration captions.

General Index

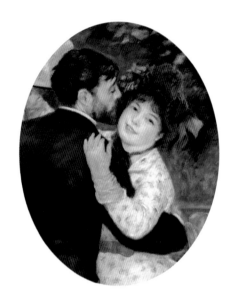

Masterpieces of Art
FLAME TREE PUBLISHING

A new series of carefully
curated print and digital books
covering the world's greatest
art, artists and art movements.